Photoshop
Made Easy

Photoshop
Made Easy

photographers'
pip
institute press

Nick Sullivan

First published 2006 by
Photographers' Institute Press / PIP

an imprint of Guild of Master Craftsman Publications Ltd
Castle Place, 166 High Street,
Lewes, East Sussex BN7 1XU

ISBN 1 86108 472 2

Production Manager Hilary MacCallum
Managing Editor Gerrie Purcell
Photography Books Editor James Beattie
Managing Art Editor Gilda Pacitti

Set in Meta Plus
Colour origination by Wyndeham Graphics
Printed and bound by Sino Publishing House Ltd, Hong Kong, China

Contents

Photoshop **Workflow** Made Easy

Understanding file formats

If you're new to digital photography then the first thing to get to grips with is the various **file formats** used by digital cameras. At first this can seem a lot more confusing than the simplicity of film; however, it does provide you with a wealth of useful options.

When making the decision of which file format you wish to save your images in you may be limited by the options that your digital camera offers. Many digital compacts save only in jpeg format, offering you a choice of compression and image size that will determine how large the resulting photograph can be displayed on screen or printed out. Higher-specification digital compacts and all digital SLRs will offer you a wider choice of file formats, offering jpeg, raw and sometimes tiff files as well, each of these is explained below.

Hints and tips

Re-saving an image repeatedly as a jpeg effectively loses more quality as it is compressed each time it is saved. Although the loss is only gradual (depending on the compression setting), after many re-saves you start to lose more detail from the image. Saving to another, non-lossy, file format such as tiff will avoid this happening on future re-saves.

Jpeg files

The jpeg file is one of the most common files used in the digital world. The format is both instantly accessible by Macs and Windows-based PCs and is popular for use on the internet. If you're wondering where the name jpeg comes from, it simply stands for joint photographic experts group, after the group which developed it. The suffix of the filename itself will be '.jpg'.

The main feature of jpeg files is that they are compressed in order to keep the overall file size as small as possible. This is advantageous as they use less space, making them good for the internet and also good for digital cameras as you can store more information on your memory card and thus take far more images. They are also more convenient for sharing as they are often small enough to send as email attachments.

The advantages of compression come at the expense of quality. Jpeg files are what are known as 'lossy' files, the more you compress the data the more image quality is lost. Therefore if you save your jpeg images in your camera at the highest quality setting you will lose the minimum amount of information. This is also true when you are saving your files on computer as well. In Photoshop you can choose how much compression you want. Saving your jpeg image at maximum quality keeps as much information as possible, while saving at low quality keeps the overall image size very small and loses a lot of quality.

The image above left is a jpeg file saved at the low-quality setting while the image on the right was saved at the maximum-quality setting – the images are in close-up to show the effects of the file saving settings more clearly. The low-quality image on the left has become fairly soft and is no longer very sharp while the high-quality jpeg file has retained more definition and better contrast.

Because a jpeg has variable compression settings you can judge the balance of convenience versus quality and make a decision as to which compression setting offers the best compromise.

Tiff files

Tiff files have been designed for a variety of applications, including photography, and are the files of choice for professional printing and production. The acronym of the format itself stands for tagged image file format, and the suffix of the filename is '.tif'.

In the tiff dialogue box you have the important options of saving the image with no compression or with compression. Tiff files support a lossless form of compression known as LZW (named after Lempel Ziv Welch). When you go to save a tiff file you will be given the option to save as a straight tiff file, a tiff with LZW compression, or with zip or jpeg compression. You will also be prompted to specify the byte order you want the file saved as; unlike jpeg files, a tiff file has to be designated to work with either the byte order of Windows-based Pc's or Macs. You will still be able to view an image saved with an IBM PC byte order on a Mac and vice versa, however, you may find that the colours are not as consistent as they should be.

Raw files

Raw files are certainly something you need to know about if you are serious about digital photography. As with all things there is a time and a place for the raw file. Jpegs have their place for quick recording and keeping storage space to a minimum, but the raw file is at the opposite end of the spectrum and is all about image quality and preserving as much information from the original image as possible.

Confusingly there are many variations of raw files. Each camera manufacturer has its own raw file format (normally several as they are updated to accommodate new camera models), which is unreadable unless a particular software device is enabled to read it. The nature of a raw file itself is somewhat explained by its name; the raw file is pure uncompressed data and has had no alterations made to it by the camera. The image itself is not subject to any colour correction, preset curves or even sharpening so you literally get a pure 'digital negative' from the camera, a true original. In fact these images can often look far from appealing when they come out of the camera, but this is the very idea behind them. By having a pure file you can make your own choices over how to manipulate the image and get the optimum final image. Raw files are of great significance for photographers as they offer a manageable file size (smaller than a tiff file) while offering the best chance at getting the highest quality achievable. In fact when working with raw files it's always best to keep your original raw file intact so you have an original, as you did with your film negatives.

I have already mentioned that raw files need to be opened by suitable software. Most digital cameras come equipped with software designed just to open the specific raw file of the camera that you own, and often other cameras in that manufacturer's range. However, things dramatically changed when Adobe introduced a plug-in for Photoshop 7 that would open a range of different digital camera raw formats. By the time Photoshop CS came on the scene myself and others were delighted to see that Adobe had built in the raw plug-in as standard. However, the limitations with this were that you could open only one raw file at a time. Adobe has been quick to learn and CS 2 now has the ability to open multiple raw files. The latest versions of Elements also offer built-in raw support for raw conversion, and these are simple to use via a series of sliders that offer control over the various shooting parameters, although the full version of Photoshop does offer greater flexibility.

Jargon Buster:

Digital negative files (DNG)

DNG stands for digital negative. It is a format designed by Adobe in the hope that it might provide a universal raw file and bypass the problems caused by no two raw formats being the same. While few manufacturers use this format you can convert your raw files yourself using Adobe's free DNG Converter, so for more information visit www.adobe.co.uk/products/dng/main.html

Making a contact sheet

Once you've shot your images no doubt you'll be itching to get stuck into them. However, creating a **contact sheet** is the first step to organizing your images, and can be helpful to people who are receiving your images.

Organizational skills are important in digital photography, otherwise you will end up with thousands of unidentifiable files clogging up your computer. The first step is to create a contact sheet – a reference for all the images within a certain group. The sheet or sheets

display thumbnail images of all the pictures contained so you can see which images are stored on a particular disc. Photoshop allows you to make customized contact sheets of your images, and this tutorial shows you how to produce a set of contact sheets for CD cases.

1 Opening the contact sheet

The first thing to do when creating a contact sheet is simply click on **FILE → AUTOMATE → CONTACT SHEET II**. Once you do this a dialogue box will appear. You have a number of options that you can play around with here, the key ones to consider are the dimensions of the contact sheet you are going to create. In this case I wanted to create a small contact sheet that will fit into a CD case. I need to set the dimension to 4.75 x 4.75in (12.065 x 12.065cm) to get the right size. You can go for six

columns by six rows which will make a nice even configuration for the final case presentation. You can put the resolution to just 72dpi as, at this small size, it's very hard to notice any loss of quality at 72dpi and it will print quicker. One last thing I'd recommend changing is the font size, make it around an 8pt font as any long names in a larger font size get truncated by Photoshop when you make the final contact sheet.

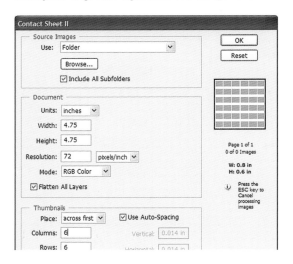

2 Selecting the images

The next thing you need to do is to select the groups of images you want to use, whether they are on disc or in a folder on your computer you can access them by clicking on the **BROWSE (CHOOSE** for Macs) button, you can navigate from here to any image folders and files on your computer or loaded CD or DVD. Just find your folder click on it then click **OK**. Then click **OK** in the contact sheet II dialogue box and simply sit back and watch Photoshop go to work as it arranges the images on your page.

3 Processing

How long it takes to load the images onto the contact sheet will depend on the size of the images and the processing power of your computer; Photoshop CS 2 can place raw files onto a contact sheet, but it can be a slow process. At this point your contact sheet is a layer that you will need to flatten before you can save the image. To do this simply choose **LAYER → FLATTEN IMAGE**. You now have the contact sheet ready to print out for your CD case.

Hints and tips

If you have a mixture of portrait and landscape images then you can end up with some very small thumbnails on your page. If you want to squeeze more images onto a page and keep all the images the same size you may want to select the **ROTATE FOR BEST FIT** option in the contact sheet II dialogue box. Simply check this box and all of the images that you select, whether portrait or landscape, will be kept in the same format.

The latest versions of Elements offer a similar contact sheet function, but via a different route. Simply select the images you wish to print as a contact sheet. Then click **FILE → PRINT** and select the contact sheet option under **SELECT TYPE OF PRINT** then alter the **SELECT A LAYOUT** options including the number of columns according to your requirements. You will be shown a preview to the left of the control panel. The dimensions and print settings of the contact sheet can be altered via the **PAGE SETUP** button.

4 Creating a border

Before making your print you can do one last thing to make the process easier. Putting a narrow grey border around the image will help you see where you need to cut the sheet to fit your CD case. Simply go to **IMAGE → CANVAS SIZE**, from here a dialogue box appears as above. Now change the canvas extension colour to grey and then increase the width and height by about $1/4$ in (5mm) to create some grey canvas around the image. Leave the white box in the middle and click **OK**. The image will now have a grey edge around it and you can send it to print, **FILE → PRINT**. Once printed you can carefully cut out the image around the edge (best done with knife and metal ruler on a board, or a guillotine/trimmer) and then you have a contact sheet ready for your CD case.

All the printed item needs is to be slid into the case and you have the final result. Presenting a contact sheet in this way will help you keep organized as well as looking like you're a real pro in photo presentation.

See also:

▶ Using the file browser, *page 14*

▶ Using metadata, *page 17*

▶ Using keywords and flags, *page 19*

Jargon Buster:

dpi and ppi

You will often hear the term dpi used in relation to prints and printers. It is simply a measure of the resolution of a printed image in terms of 'dots per inch', it is similar to ppi which stands for 'pixels per inch' and is a measure of the resolution of an image on a screen. The more dots per inch the higher the resolution for a given area.

5 Making contact sheets in Windows XP

Here's a little trick worth noting, if you really haven't got time to even open Photoshop and you want to make a quick contact sheet then Windows users can actually make one directly in Windows XP. Simply find the folder of images that you want to work with, whether on your desktop, CD or memory

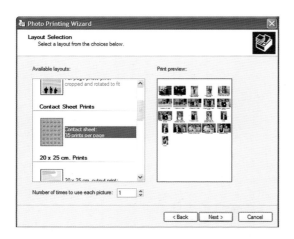

card. Once in your folder of images click on the first image and then go to **PRINT THIS PICTURE** under **PICTURE TASKS** on the left. From here a dialogue box will appear saying **WELCOME TO THE PHOTO PRINTING WIZARD**, all you need to do is click **NEXT**. Then you will see all of the pictures from your chosen folder, the first image will have a tick in the check box, you can go through and select the images you want to use by ticking the boxes, or by clicking on **SELECT ALL**. Once you're happy with the selection click **NEXT**. The box that appears allows you to choose the printer and any printing preferences you have, set these up accordingly and click **NEXT**. The next step is where you finally get to select the contact sheet function. On the left of the dialogue box you will see a number of different layout options to choose from. Simply click on the **CONTACT SHEET** option, from here click **NEXT** and Windows Photo Printing Wizard will send your images to the printer – simple!

6 Making alternative contact sheets

If you want to make a traditional-style contact print on one sheet of paper then you simply need to change the setting at the outset of the process. When you open the contact sheet II dialogue box simply put in the dimensions of the sheet you are printing. Now the next key thing to do is to decide how many rows and columns of images you want to

appear on your sheet. The higher the number of images in each row the smaller they will be on the contact sheet. I would recommend experimenting with the layout of contact sheet you want. Try, for example, four columns and four rows – this provides nice large images while still placing 16 (portrait-format) images on one sheet.

Using the file browser

Photoshop has many wonderful functions, but it is easy to overlook one of the fundamentals of image processing, the simple act of finding and opening the picture in the first place. That's why Photoshop's **file browser** is so important.

While some users may simply opt for the **FILE →** **OPEN** *route the file browser is more versatile as it acts like a virtual contact sheet allowing you to view all of your images and then select the one that you want to open. The file browser is a powerful tool, one that can be modified for the convenience of the Photoshop user, and this tutorial introduces some of the different*

functions. Photoshop CS 2 offers access to the latest version of the file browser in the form of Adobe Bridge. This tutorial is designed for users of the older version of the file browser found in Photoshop CS and older versions, however many of the functions here apply to Adobe Bridge as well. Users of the latest versions of Elements can simply rely on the Organizer part of the software.

1 Browser basics

To start with you can access the file browser in one of two ways, either by selecting **FILE → BROWSE** or by selecting the browser icon () in the main Photoshop screen which is located in the top right-hand corner of the toolbar. When the browser is open you have the standard-format browser screen. In the top left-hand corner you can see all of your folders and items that are located on your desktop and any sub-directories such as 'my computer'; this area is known as the palette area. Depending on which folder or file you select the relevant group of thumbnail images will appear displaying a thumbnail of each and every image and also the name of the file. If you click on any of these images the individual image will be shown in a larger preview box on the left-hand side. When you double click on any of the thumbnails the corresponding file will automatically open as the main image in Photoshop.

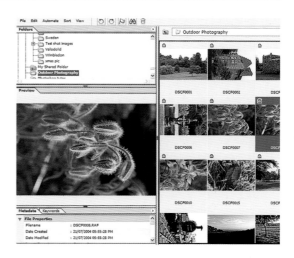

The final section is the metadata in the bottom left-hand corner. This information includes all of the file properties of the image, from the creation date to the useful details of shutter speeds and apertures.

2 Points of view

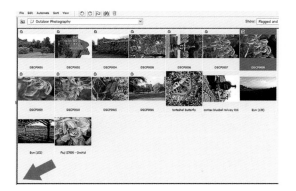

Now you can play around with the format of your file browser layout. In the bottom left-hand corner there are a set of arrows, this is the expanded-view icon (see the red arrow) which controls the expanded-view mode, by clicking on this the folders, preview and metadata disappear allowing you to concentrate on the thumbnail images. It is worth noting that from here you can move around the images simply using the cursor keys. Also if you want to open more than one image at a time you can do so by simply clicking and highlighting an image and then pressing the **CTRL** key (**COMMAND** key for Macs) before clicking on other images. Just press **ENTER** to open the images.

3 Thumbs up

Viewing all of the images in expanded view is good for working with, but you may find that the images are a little on the small size. This is not a problem because you can actually reset the size of the thumbnails as viewed on your screen. Simply go to **VIEW** on the file browser toolbar at the top of the screen. Click on this and a drop-down box appears. You can choose from a range of settings, however, how they appear on your screen will not always be consistent, for example the medium setting on my computer shows one thumbnail ridiculously small. That is why I choose custom thumbnail size to give me more control.

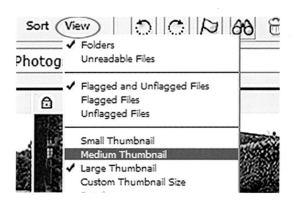

4 Going large

In custom view size the thumbnails take a jump up in size; at this point they are great for viewing and good for showing to potential clients and friends. However, you can go one better than this and gain full control of the size of the thumbnail that you create, in this case making the thumbnails even bigger for your viewing purposes.

The first step is to go to the **EDIT** menu at the top of the screen in the file browser. When you click on this a drop-down box appears and from here you should choose the bottom option – **PREFERENCES**. Once this is chosen the preferences dialogue box will appear.

5 Growing your thumbnails

In the preferences dialogue box it is the custom thumbnail size that you are concerned with. In this case the default was set to 240 pixels wide. This can be changed to 300 pixels wide to make the thumbnails even bigger for viewing purposes. Once this is done simply click **OK**.

Now the size of the thumbnails is increased you can get a much better feel for all of the images that are held in this folder and make better decisions about which ones you choose to work with.

6 Going into detail

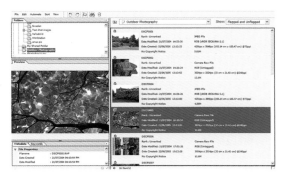

An alternative is to add detail to your thumbnails by going back to the **VIEW** menu in the file browser toolbar and choosing the **DETAILS** option. This gives you smaller thumbnails, but also displays some very useful information including the file type, size and resolution.

Hints and tips

🖱 Once you've previewed your images in file browser you may well want to create a contact sheet; you can do this by going directly through file browser, simply select the images you want and select **AUTOMATE > CONTACT SHEET II**. From here you can choose the document size and how many rows and columns you wish your images to be placed on to make the final contact sheet.

🖱 When you open the file browser it may well be the case that you simply want to open an image through file browser and then close the file browser itself. In order to do this simply press **ALT** and double click on your image, this will open the image and automatically close file browser.

🖱 It's worth noting that you can increase the size of the preview area by closing the folders directory and the metadata window.

See also:

◀ Making a contact sheet, *page 11*

▶ Using metadata, *page 17*

Using metadata

One of the beauties of digital photography is that you no longer have to keep extensive notes about your image. All of this is done by your camera and you can find this **metadata** easily within Photoshop.

When you are in the file browser window you will find the metadata information in the bottom left corner. The good thing with Photoshop is that this information is easy to view in the browser, Elements (Organizer), or Adobe Bridge, so you can find out just exactly how you created your picture. The following is a summary of what can be found in the metadata box; the two key subheadings that we want to look at are the file properties and the camera data (exif).

Jargon Buster:

METADATA

Metadata is encrypted into each individual picture you take; it is a strand of information about your picture detailing important information from file format to shutter speed and aperture. It's a great learning tool as it includes a combination of a file's technical data, and the image's shot settings. By comparing similar shots with different settings you can learn a great deal about photography.

1 Filed away

The first thing to do is open the browser again, go to **FILE > BROWSE** to bring up the browser or just choose an image in the Elements Organizer. Now select an image then look at the bottom left-hand corner where you will find the metadata information. In Elements Organizer you may have to click **WINDOW > PROPERTIES** and then tick **COMPLETE** to make the full metadata appear at the bottom right. In the file properties field you can see the basic information such as filename, file format and creation date (which is useful for sorting images). You can see the file size as well as its resolution and bit depth. Finally information on colour lets us know the colour mode and also the colour profile that has been applied to that image.

Metadata Keywords	
▽ **File Properties**	
Filename	: DSCF0020
Document Kind	: JPEG file
Application	: Digital Camera FinePixS...
Date Created	: 26/05/2005, 12:52:18
Date File Created	: 26/05/2005, 13:52:22
Date File Modified	: 26/05/2005, 13:52:22
File Size	: 4.37 MB
Dimensions	: 4256 x 2848
Resolution	: 72 dpi
Bit Depth	: 8
Color Mode	: RGB Color
Color Profile	: sRGB IEC61966-2.1

2 Camera data

After looking at file properties you will find the next field is the IPTC metadata. This is a field where you can enter your own data about the image for your record purposes. In this case we will move straight on to the next field, that of the camera data (exif). Exif data is very useful as it helps you understand your image. First there is the exposure, probably the most important single factor, reminding you of your shutter speed and aperture. If you were working with any exposure compensation then this can be seen in the exposure bias value. Further down you can see the ISO setting for the image and even the exact focal length that was used. As you go further down there is even more precise information on white balance settings and the level of sharpness set on the camera.

▽ Camera Data (Exif)	
Exposure	: 1/350 s at f/11
Exposure Bias Value	: -0.5
Exposure Mode	: Auto
Exposure Program	: Aperture priority
Brightness Value	: 8.83
ISO Speed Ratings	: 200
Focal Length	: 32 mm
Focal Length in 35mm Film	: 48 mm
Software	: Digital Camera FinePixS…
Date Time	: 26/05/2005, 12:52:18
Date Time Original	: 26/05/2005, 12:52:18
Date Time Digitized	: 26/05/2005, 12:52:18
Flash	: Did not fire
Metering Mode	: Pattern
Orientation	: Normal
EXIF Color Space	: sRGB
Custom Rendered	: Normal Process

Hints and tips

Really try to make use of metadata as a learning tool. If something went wrong with your images then look at your metadata; maybe you had the wrong white balance setting, maybe you used the wrong amount of exposure compensation. Metadata helps you learn about photography and find out what went right or wrong when you took the image, so next time you're taking pictures you can apply what you learnt from your metadata.

If you want to neaten up your workspace in Elements Organizer then choose **WINDOW > DOCK PROPERTIES IN ORGANIZE BIN** to lock the properties window to the right-hand side of the workspace.

See also:

◀ Understanding file formats, *page 8*

◀ Using the file browser, *page 14*

▶ Using keywords and flags, *page 19*

Using keywords and flags

Now that you have seen how the file browser works and how it can be used it is time to take it a step further by looking at how to categorize images within Photoshop by using the **keyword** function.

Keywords allow you to designate images under a heading name which can be used for searches at a later date. Combined with the flagging function, you can mark out specific files that you want to work with and organize them appropriately, making it far easier to find them later.

1 Creating keywords

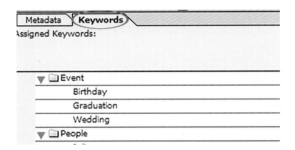

The first thing to do is to return to the file browser screen, this can be done via **FILE > BROWSE** or simply by clicking on the file browser icon in the top right-hand corner of the toolbar. Once in the file browser locate the **KEYWORD** function which is situated down to the bottom left-hand corner of the file browser screen, you'll notice there are two tabs there, one with **METADATA** and one with **KEYWORDS**. By default it will be set on **METADATA** so simply click on the **KEYWORDS** tab to bring this function into play. Once you do this you will notice that there is a host of preset subject matters already designated as keywords, which you can keep or delete as you wish.

In order to create a new keyword all you need to do is go down to the bottom of the keyword dialogue box, there are three icons along the bottom, and the one in the middle is the **NEW-KEYWORD** function.

2 Folders for flowers

The next step is to create a new keyword folder, in this case I created one called 'Flowers', so that I can look for all of the flower images within a certain folder. Once your folder is created you need to select all of the images that you want to designate under the keyword. To do this all you need to do is simply select all the relevant images within the folder that you are currently looking at. By holding down **CTRL** (**COMMAND** key on Macs) and clicking the mouse you can select all of the images one by one that you want to assign to that folder. All you need now do is double click on the folder and all the images selected will be designated to it.

PHOTOSHOP WORKFLOW MADE EASY

3 Search parties

The next step is to practise searching for the images that have been designated to that keyword. To do this you need to perform a search within file browser. In the top centre-left of the file browser toolbar is a binocular icon, click on this to engage the search function, to search under keywords change the left-hand criteria drop-down box to **KEYWORDS** and type the keyword that you're looking for into the right-hand box, in this case it's **FLOWERS**. Once done click **SEARCH**.

4 Search results

Once the search is completed you are left with the file browser displaying only the images that have been assigned to the keyword 'flowers'. This method allows you to search for flower images within a folder again in the future, and with the flower folder active in the keywords palette you can always add more images to this keyword at a later date.

5 Raising the flag

Moving away from keywords, it's time to introduce a quick method for organizing images. In the file browser you are able to place little flags on each image as a quick way of identifying preferred images. Simply open a folder of images and start flagging the ones that you wish by either clicking the flag icon in the file browser toolbar or simply hit **CTRL** and ' (apostrophe key) or **COMMAND** ' on Macs. This way you can quickly move through the images, placing flags where you choose.

6 Finding the flags

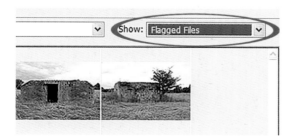

Once you've finished flagging your files you can choose to take a look at all the files you have chosen by making use of the **SHOW** drop-down box. Just click on the drop-down box and choose **FLAGGED FILES**, then you can view all of the flagged files; a great organizational tool!

See also:

◀ Making a contact sheet, *page 11*

◀ Using the file browser, *page 14*

◀ Using metadata, *page 17*

7 Stepping back

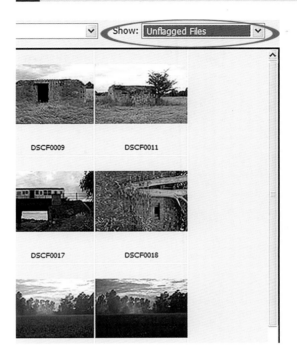

Show: Unflagged Files

DSCF0009　　DSCF0011

DSCF0017　　DSCF0018

Finally, if you feel the need to go back and look at those images which you didn't flag to see if you have made the right decision then you can simply go back to the **SHOW** drop-down box and choose **UNFLAGGED FILES**, and your unflagged images will appear. Simply flag any more images and return to the flagged files when ready.

Using keywords and flags

Hints and tips

🖰 As mentioned earlier the pre-assigned keywords that are set up in Photoshop's file browser will often not be appropriate for your needs. You can simply delete them by clicking on the main item and then right clicking (**CTRL** click for Macs) and choosing delete.

🖰 The process of tagging and keywording is even easier in Elements Organizer. Simply click new in the tags box at the top right of the workspace. Then select **NEW TAG, NEW SUB-CATEGORY OR NEW CATEGORY**, before giving the selection a name, an appropriate icon and a colour of your choice.

Once you have done this simply right click on an image, select **ATTACH TAG** and choose the category and tag that you wish to allocate to that image. Once you have done this for all of your images you can search them by clicking in the blank check box by the side of the relevant category in the tags window. When the selection is shown a binoculars icon is shown in the check box. You can search more than one tag at the same time for more specific results. Simply click on a number of categories or tags and tick the **BEST** check box at the top of the screen. This will allow you to search for images that fulfil two or more criteria.

Cropping & Resizing Made Easy

Using the crop tool

In this section I will show you how to use the **crop tool,** how to set up the appearance of the crop tool and some of the crop tool presets which you may well want to put into use.

1 Cream of the crop

The crop tool is the icon with the intersecting cropping frames as shown on the toolbar above, pressing **C** will instantly engage the crop tool. At the top of the screen the crop tool toolbar will appear as the crop tool is selected.

2 Making the crop

Making the crop could not be easier. Simply click and hold down on the point where you want your crop marquee to start from, in this case it's the top left-hand corner, then drag the marquee line to where you want your crop to end and let go. You can now see the selection you have made, outside of the crop marquee is the crop shield, in this case a transparent black, which indicates the area that will be erased.

3 Cutting off the excess

The simplest way to execute the crop is to just hit the **ENTER** key, and straight away Photoshop will go about discarding the extraneous area. Alternatively select **IMAGE → CROP** or click the **TICK** icon.

See also:

▶ Straightening horizons, *page 28*

Jargon Buster:

Perspective crop

Photoshop offers the option of adjusting the perspective while you crop an image. Ticking the perspective box means that you are able to move the points that define the boundaries of the crop independently. This enables you to correct perspective distortion, such as converging verticals, by positioning the boundaries of the crop parallel to a line that you wish to appear vertical in the final image. Confirming this crop will cause the image to be cropped along the defined border and then remapped so that it appears rectangular on the page, hopefully with the perspective corrected. In Elements this can be performed by selecting **IMAGE → TRANSFORM → PERSPECTIVE** and adjusting the points in the same way.

4 Coloured shields

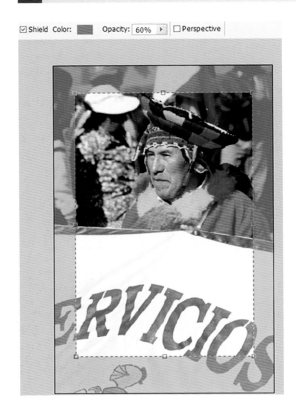

Now if we just rewind a step and go back to the point of cropping I want to show how you can actually change the crop shield in the image. In this case I changed the crop shield to be a red colour. In the crop toolbar at the very top you can see there is a **SHIELD COLOUR** box and also an **OPACITY** setting. This particular function can only be engaged when you are performing a crop. If you double click on the **SHIELD COLOUR** box then the **COLOUR PICKER** box will appear, from here you can choose any colour to become the crop shield colour. In this case I chose red which really stands out well, I also chose to place the opacity at 60% which makes the red quite strong but still translucent enough to see through to the image. This can be really useful when you are cropping a night shot and the default black crop shield is hard to see. Unfortunately this option is not available to users of Photoshop Elements.

5 Custom crop sizes

It's also worth knowing that in the crop tool you have a number of preset crop functions for popular crop sizes that are desirable for common print sizes. Simply click on the drop-down arrow next to the crop symbol in the top left-hand corner. This will then display a choice of different sizes such as 4 x 6 and 8 x 10 inches. The crop presets will also automatically reset the resolution to 300 ppi, perfect for reproducing quality prints (see resizing the image, page 37). Choose a preset, then when you click and drag your marquee Photoshop will work around the parameters of the size you chose, restricting any selection by only allowing this size to be produced from the final crop.

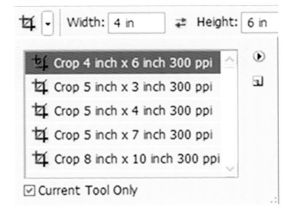

6 Front image

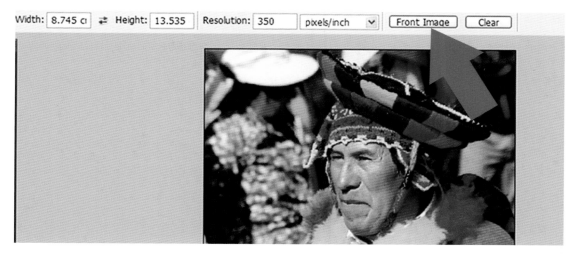

Width: 8.745 c� ⇄ Height: 13.535 Resolution: 350 pixels/inch ⌄ Front Image Clear

Clicking on the **FRONT IMAGE** button on the toolbar not only shows you the size and resolution of the image, but it allows you to alter the crop while maintaining the aspect ratio (the ratio of height to width) of the image. While **USE PHOTO RATIO** does the same thing in Elements.

7 Swapping sides

⌷ ▾ | Width: 10 in ⇄ Height: 8 in

If you are working with a preset size, let's say 10x8in, it's worth noting that you may need to swap the dimensions around if you need, for example, to work with a 8x10in portrait image. In this case just click on the two arrows between the width and height fields to switch the values around. It's also worth knowing you can choose other dimensions, just type in any value you want in the width and height boxes. You can also resample the image at the same time (see page 37) by typing a value into the resolution field.

Hints and tips

When you have finished with a preset crop tool, either from Photoshop or your own, and you no longer want to use it any more, just click on the crop icon in the top left-hand corner and select **RESET TOOL** return to the standard cropping tool.

If you have drawn a marquee, but change your mind and no longer want to crop the image, simply click the cross or stop icon depending on your version of Photoshop.

Straightening horizons

Certainly no-one is perfect in their photographic endeavours and I'm sure we have all taken the odd picture with the horizon not straight. This tutorial shows an extremely simple technique here for quickly **straightening horizons** by simply making a selection and then rotating the image to suit.

Before
Misaligned horizons, even those that are only marginally off true, can be extremely distracting, really drawing the eye from the main elements of your image.

1 Making a selection

First engage the rectangular marquee tool (**M**). With this tool engaged simply draw a selection around the image, dragging from the top left-hand corner to the bottom right.

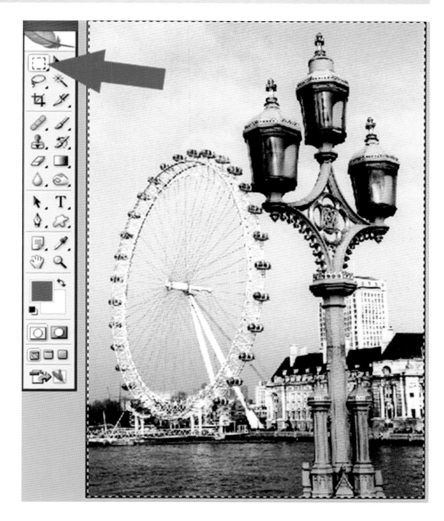

Hints and tips

It's worth noting that when you want to straighten horizons you may want to make use of the grid system in Photoshop to line up the horizontal and vertical lines in the image, simply select, **VIEW → SHOW → GRID** or in some versions **VIEW → GRID** to place a cross grid system on the image.

2 Rotation time

Next you need to rotate the image within the selection just made. So choose **EDIT →
TRANSFORM → ROTATE** or **IMAGE → ROTATE →
FREE ROTATE LAYER**

3 Tilting Thames

With the **ROTATE** function activated all you need to
do is click outside the image (if necessary expand
the window so that the canvas is visible) and drag it
to even out the horizon line, once done press
ENTER to apply the change. Note that if you click
and drag within the image this will move the
selection and not rotate it.

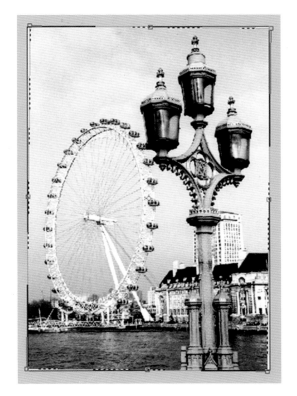

4 Creating a crop

The next step is to crop the image, as rotating it will leave some blank canvas at the corners of the image. Select the crop tool (**C**) and then crop the image down to cut out the offending sections.

See also:

◀ Using the crop tool, *page 24*

After

And hey presto, here is the final image. There is still some distortion but the overall appearance is more level. This is a really simple trick to memorize and is particularly useful for shots with prominent horizons such as landscape shots.

Auto crop and straighten

If you have a group of images that have been scanned in one hit and you need to crop them and also straighten them you'll be glad to know Photoshop has a handy **auto crop and straighten** tool that will lighten your workload no end.

Making scans of multiple images should be a way of hastening the transition from film to digital; but it can leave you with a great deal of further work before your images look right on screen. However, Photoshop can automate this process for you making it much easier.

See also:

◄ Using the crop tool, *page 24*

◄ Straightening horizons, *page 28*

Before

These two images were scanned on a flatbed scanner and have not been lined up properly. I could have rescanned them and started again but the automatic crop tool is adept at both straightening the images and separating them out into separate files.

1 Automatic crop

The first thing to do is to engage the automatic crop tool; to do this select **FILE → AUTOMATE → CROP AND STRAIGHTEN PHOTOS**. Alternatively **IMAGE → DIVIDE SCANNED PHOTOS** will do the trick in Photoshop Elements.

Hints and tips

This method can work for single images as well as groups, so if you're short on time and need a quick fix don't forget to put it to good use.

2 Straight and separate

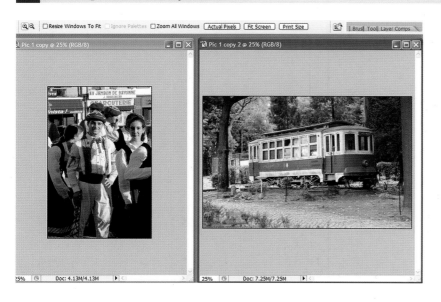

Photoshop will crank and grind for a few moments as it not only separates the images out but also crops and straightens them at the same time. All you need to do now is make sure that you save each new image with an appropriate name and delete the original source file.

Using rulers

When assessing an image you may wish to use the **rulers function** to map out its internal dimensions and scale. This tutorial shows you how you can display the rulers and change them to display different measurements and increments – a great way of making your compositions more precise.

1 Spanish flavour

The first step is to switch the rulers on, as when you open an image, such as this shot of Salamanca in Spain, Photoshop has the rulers function switched off by default.

See also:

◀ Using the crop tool, *page 24*

◀ Straightening horizons, *page 28*

▶ Resizing the image, *page 37*

2 Selecting rulers

To select the rulers simply choose **VIEW → RULERS**.

Hints and tips

You may want to combine rulers with a grid, simply choose **VIEW → SHOW → GRID** to combine a grid across your image with the rulers.

Note that its not just physical measurements you can show with the ruler, there are other options as well. One you might want to try using is percent, which marks the image as a percentage of the total size in numbered increments.

3 Rulers on display

Now you have rulers along the top and side of the image, the default setting is inches, if you zoom in or out they will adjust to represent the correct size of the image. The rulers enable you to better judge the proportion and composition of the image, helping with cropping and printing.

CROPPING & RESIZING MADE EASY

4 Changing to metric

If inches are not for you, and you want to work in metric measurements, then this is no problem at all. Simply right click (**CTRL** click for Macs) anywhere along the ruler and you can then change the dimensions to a unit of measurement of your choice, including pixels, inches, centimetres, points, picas and percent.

5 Different measures

And here is the image with centimetres as the unit of measurement format. You can also change the format to millimetres if you prefer (depending on your version of Photoshop). Now you can simply put the rulers into action any time you need them and turn them off when they are not required.

Resizing the image

It's surprising to note how many people don't know the simple and fundamental action of **resizing an image** to obtain the correct resolution. Many cameras, when shooting in jpeg mode, will reproduce an image at a default 72ppi. This resolution is fine for viewing purposes on a computer screen or for use in web publishing, but not very good when it comes to making a final print.

One way to change the resolution is to crop the image and change the resolution in one step (see page 24, Using the crop tool). However, if the image doesn' t need cropping then you will need to change the image resolution directly

through the image-size command. This is extremely simple to do and I'd recommend you get into the habit of doing it automatically so that any future prints that you create are of optimum quality.

1 Using image size

In image size you can change your image dimensions as you please, but you can also change the resolution as well. Go to **IMAGE → IMAGE SIZE, (IMAGE → RESIZE → IMAGE SIZE** for Elements) the pop-up box will look like that to the right, and generally if you are working with a new jpeg image the resolution will be set at 72ppi.

2 Resample image

The next step is so simple yet is crucial to the quality of your digital output; click off the **RESAMPLE IMAGE** box at the bottom of the **IMAGE SIZE** dialogue box.

See also:

◄ Using the crop tool, *page 24*

3 New resolution

Now with **RESAMPLE IMAGE** unchecked you can go ahead and change the resolution, in this case I changed it to 300ppi. Doing this will change the physical size of the image – giving you an idea of the maximum print size at that resolution. With 300ppi selected this gives you an indication of the maximum size that the image can be printed at high quality. Once satisfied with your settings click **OK**.

When you work with the image size always make sure that that the **CONSTRAIN PROPORTIONS** box is checked. This function makes sure that if you do resize the width or height of the image manually the image dimensions are kept in proportion to each other and no distortion occurs.

If you are planning to print your image 10x8in (25.4x20.3cm) or larger I'd recommend using a resolution of 300ppi to get the best results. If you are working smaller than this then you can generally get away with a lower resolution, let's say around 150–200ppi, but if your work needs to be high quality, for example if it is printing in a magazine, you will always be expected to provide images with a resolution of 300ppi.

If you feel that your image is not large enough to print or display at the size you want to, then you can interpolate it. This doesn't just resize the image, but resamples it, creating new pixels, with values estimated from existing ones. To do this simply check the **RESAMPLE IMAGE** box, before you key in the required resolution and dimensions; it won't be perfect but it is normally better than just printing a lower-resolution image.

In terms of the interpolation methods which are displayed at the bottom of the **IMAGE SIZE** dialogue box it's worth knowing which ones are best to use. **NEAREST NEIGHBOUR** works as the quickest method but it's the least precise and is best for resizing illustrations. **BILINEAR** is used for bitmap images and creates a medium-quality image. **BICUBIC** is the one that photographers use, creating excellent transitions between the tones of our images.

It's an interesting little fact that if you only increase the image size by 10 percent at a time then minimal image degradation will occur. This is a fantastic way of increasing image size while retaining quality. The best way to do it is to change the unit value using the drop-down arrows in **DOCUMENT SIZE** to percent, then type in 110 percent and only increase the image in these increments each time. Also make sure that you only use **BICUBIC** as the interpolation method to increase the size.

[3]

Exposure Made Easy

Using levels

When it comes to post-capture exposure manipulation it can be tricky to decide where to start, but perhaps the best place is the simple yet powerful image exposure tool – **levels**.

It's quite common that the bright and colourful image that you viewed on your camera's LCD monitor looks a shadow of itself once brought up on the screen in Photoshop. Do not fear, there are very few pictures that will look perfect when brought into Photoshop. Levels can be used to quickly enhance an image and bring it back to life. Basic levels can be quickly mastered and will soon give you new-found confidence as you learn how to control highlights and shadows.

Introducing histograms

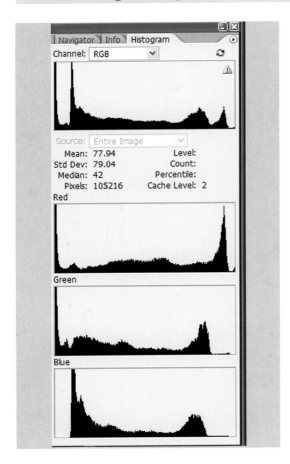

A histogram is effectively a graph that shows the distribution of tones within an image. To start working with histograms, just open any image and once open you can bring the histogram into view by clicking on **WINDOW → HISTOGRAM**. To get a clearer view of your histogram click on the arrow button in the top right-hand corner of the histogram box and select **ALL CHANNELS VIEW** (not available in Elements). You will now have four different histograms to look at. The key one is at the top, this shows the distribution of tones throughout the image. To the left-hand side you have the shadow detail, to the far right-hand side you have the highlight detail. A good image should have a curve that runs from the left to the right with no large peaks or troughs; although some images have more dynamic histograms, for example, city nightscapes. Below the main histogram are the histograms for the red, green and blue channels; these show you the distribution of tones in each colour channel that makes up the image. Individual colour channels have to be viewed one at a time in Elements.

Histograms are very useful and it's worth getting accustomed to them, they are a quick way of checking exposure, even as you are shooting images, and are invaluable learning tools.

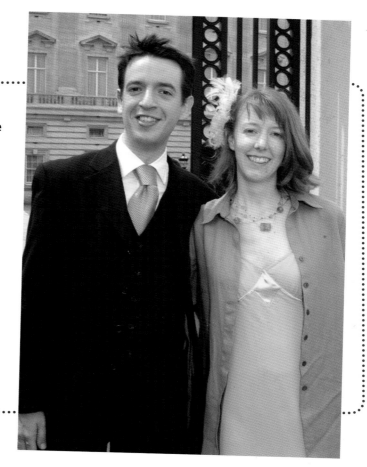

Before

This picture was taken outside Buckingham Palace after an investiture ceremony; the overall image looks a little flat and could do with a boost from levels. To start with I needed to open the levels function which can be quickly obtained by selecting **IMAGE → ADJUSTMENTS → LEVELS** or **ENHANCE → ADJUST LIGHTING → LEVELS** in Elements.

1 Getting on the level

Now after selecting the levels function you can see the levels dialogue box. Technically you are looking at another histogram, however, it's a histogram you have the power to control. This histogram has a set of slider arrows at the bottom; moving any of these with the mouse will change the tonality of the image. The far left-hand slider controls the shadows while that on the far right controls the highlights and the middle cursor controls the mid-tones. At the moment you are looking at the levels function through the RGB channel which means any alterations will affect all of the colours of the image.

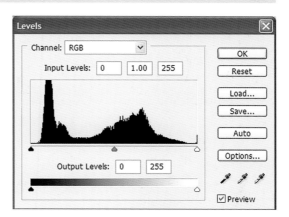

2 Pulling in the sliders

Starting with the shadow and the highlight sliders, drag the **SHADOW SLIDER** to the right, just to the beginning of where the shadow detail starts. Do a similar thing with the **HIGHLIGHT SLIDER**, by dragging it inwards to where the histogram ends. You can see the input levels change as you do so. Already these simple alterations are enough to greatly improve the image.

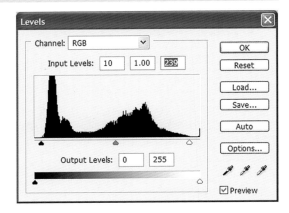

3 Contrast controlled

As you move the sliders in the levels dialogue box the image changes: now it has more contrast, the colours are more vivid and you should have more of the result that you're looking for. With the shadows and highlights set up you can now tackle the trickier mid-tone slider.

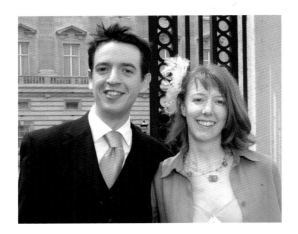

4 Middle ground

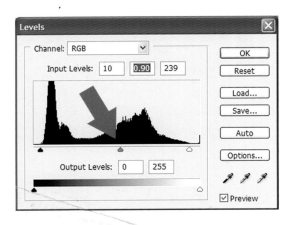

You can now make the final change by altering the **MID-TONE SLIDER**. You have to be quite precise with this one as a little change can alter the image greatly. In this case moving the slider to the right adds more density into the mid-tone detail and greatly improves the final contrast.

5 Working with output

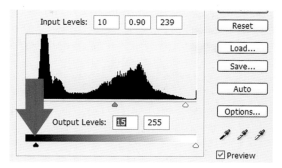

| Input Levels: | 10 | 0.90 | 239 | Reset |

Output Levels: 15 255

☑ Preview

The final thing, which often gets overlooked by digital photographers, is to make use of the output levels at the bottom. These essentially control density in the image and are a great tool when it comes to printing. By controlling density you can increase or limit the amount of ink that gets used in the final print. In this case I wanted to reduce density, saving ink but also improving print quality by limiting loss of detail in shadow areas. In this case I simply moved the **OUTPUT LEVEL SLIDER** to the right a little to reduce density in the shadow areas. And with this my image was finished.

Hints and tips

In the levels dialogue box you will see there is an **AUTO** button. This is a general quick fix which levels will perform to your image. Sometimes it produces bad results but on well-exposed images it can be pleasantly surprising; it's worth using if you have lots of images to work with and time is more of an issue than exacting quality.

It's worth noting that you can save the settings that you have input in levels. Simply choose **SAVE**. It's worth making a folder for your settings so you don't lose them. You can then load these settings through levels with another image when you choose to do so.

See also:

▶ Using curves, *page 51*

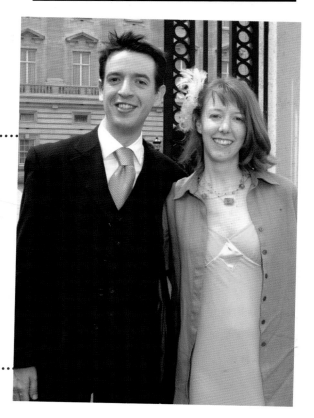

After

Here is my final image. using the levels function, I've been able to improve the contrast by adjusting the shadows, mid-tones and highlights. This is one of the simplest and most effective ways of manipulating exposure. In the next section we will take a look at some of the other functions that you can work with in levels.

Using droppers

In the previous tutorial you saw how to use levels to alter the exposure of the image, correcting the shadow, mid-tone and highlight detail accordingly. This section delves just a little deeper into the levels function by introducing the use of the **droppers** in levels.

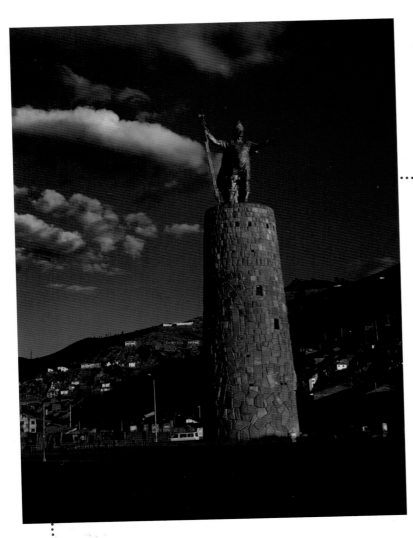

In fact droppers work as a useful function not just to control the tonality but also to control the colour of the image. This tutorial will explore how you can put droppers into action carefully and precisely to achieve good results.

Before
My image is taken from a scanned transparency taken in Cusco, Peru. The image has been rendered with an overall tonality problem, being underexposed and with colours wrongly represented.

1 Selecting levels

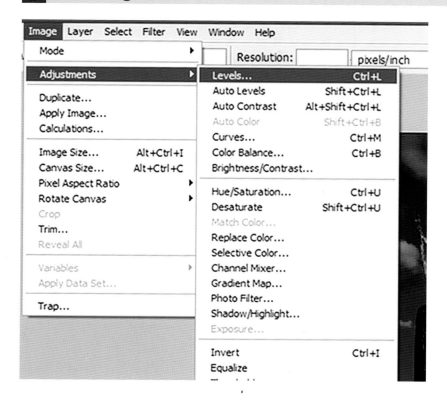

The first thing I need to do is to access the levels function, to do this I simply select **IMAGE →
ADJUSTMENTS →
LEVELS** or **ENHANCE →
ADJUST LIGHTING →
LEVELS**.

Using droppers

2 Three little droppers

Now the Levels dialogue box will appear, you can see the histogram and the sliders that you used before but this time the main concern is the three little droppers located in the bottom right-hand corner of the box.

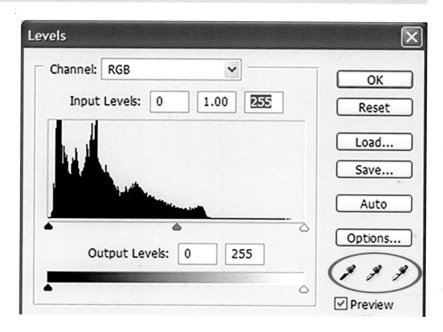

Using droppers

3 Finding the black point

The first thing to do is to set the black point; in order to do this you must find a group of pixels that are completely black in tonality in the image. Luckily there were plenty of areas in my image which represent this, so I found an appropriate area as shown by the arrow marker in the picture.

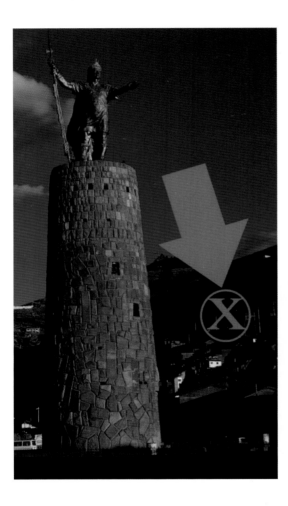

4 Setting the black dropper

With your black point in mind you now want to select this point using the **BLACK-POINT DROPPER** in the levels dialogue box. This dropper is the first dropper on the left-hand side, This will instruct Photoshop which group of pixels are black in the image, using this as a reference point Photoshop will shift the tonality of the other pixels in the image. The point you choose has to be a true black in order to render good results.

5 Setting the white dropper

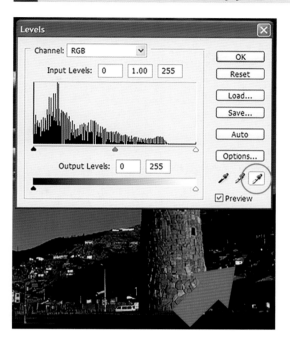

Now you can build more upon your work. Choose the **WHITE-POINT DROPPER** and find a white area, in this image the small white house works perfectly as a reference point. Simply click on the far right dropper (the white-point dropper) and then click within the image on the white point (marked by the arrow). As soon as you do this the tones of the image jump, in this case becoming lighter, as Photoshop tags the new white point and automatically changes the contrast and tonality.

6 The mid-tone dropper

The final dropper to select is the **MID-TONE DROPPER**, which is without doubt the trickiest to get right. You need to select a mid-tone grey area of pixels within the image, within this image I found such a group on the trunk of the tower. Simply select the mid-tone dropper by clicking on the middle dropper and then click on your chosen point within the image. At this point the tonality of the image should improve even more.

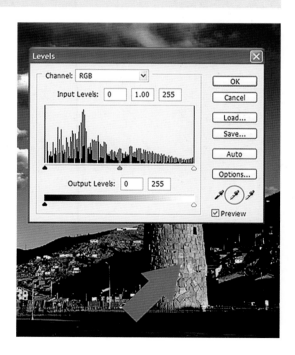

EXPOSURE MADE EASY

Using droppers

See also:

◀ Using levels,
page 42

◀ Using curves,
page 51

Hints and tips

🖱 Don't forget that if you are working with a group of similar images then after you have made alterations with levels you may want to save the changes you made to use with another image. Simply choose **SAVE**, give your settings a name and save them to an appropriate folder, when you need them again just choose to load them within the levels function.

After

With all the points set you can now click **OK** and you have your final image. The droppers have automatically colour corrected as well as altered the contrast of the image. They offer a quick way of controlling the tonality of the image by using the data you provide to let Photoshop know just where exactly a true black, a true white and a mid-tone grey lie within the image.

Using curves

After getting to grips with levels those who are lucky enough to own the full version of Photoshop will want to start using another powerful tool – **curves**. This offers greater control than levels, allowing you to add and remove density from highlights and bring back shadow details in specific areas.

It is worth noting that most scanner software makes use of a curves box with which you can make pre-scan image adjustments. This tutorial will show just how the curves tool can be put into action to change the tonality of specific areas to improve colour and tonality, adding punch to the final image.

Before
This image, taken on a digital camera, comes with bags of colour, but could be more vibrant, with improved contrast and tonality. To start with I worked on the main RGB curve channel to get the best contrast range and then moved onto using the colour channels to rectify any colour casts.

1 Using the curves dialogue box

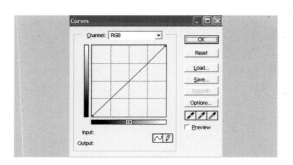

The first thing to do is to open the curves function, **IMAGE → ADJUSTMENTS → CURVES**. The curves dialogue box will appear. In fact you have no curves to start with but instead a single diagonal line. This represents the graduation from black, in the bottom left-hand corner, to pure white at the top right. Along the bottom and up the left-hand side are the gradient bars while at the top is the drop-down colour channel box.

EXPOSURE MADE EASY

2 Making a clipped curve

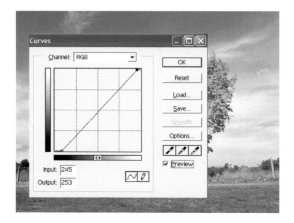

To start with I made some very small changes to the image by clipping the curve. In this case I moved the bottom (black) point to the right, and the top (white) point to the left. This creates a clipped curve that will increase overall image contrast; I have in effect lost both shadow and highlight detail to do this. Note that you could also lessen contrast by moving the black point upwards, instead of to the right, and the white point downwards instead of to the left.

3 Creating anchor points

While the clipped curve provides a quick method to increase or decrease the contrast, to harness the real power of the curves tool you need to create your own curve for each image by making subtle alterations along the line. Pressing **ALT** and clicking the mouse will convert the curves grid table from a 4x4 grid to a 10x10 grid. By clicking on a number of positions evenly along the diagonal line you can create anchor points. The more points you create the finer your control will be.

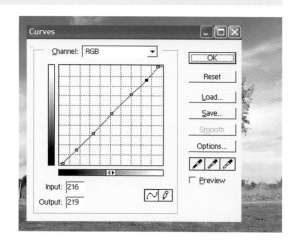

4 Adjusting the points

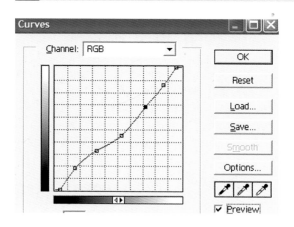

With the anchor points set across the curve you can make small adjustments by creating small curves for different parts of the image. In this case I started by pulling down the highlight points to add density to the light parts of the image. Pulling the mid-tone point down adds depth and saturation to the mid-tones, while finally the shadow points are pulled upwards to add detail to the shadow area.

5 Judging the effects

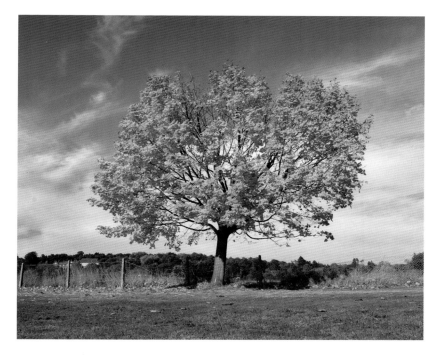

Looking at the image now you can see the effects of altering the curve. Pulling down the mid-tone points has increased the overall Polaroid-style colour density, but probably the most useful element is using the shadow points to make refined improvements, adding subtle detail. If you want you can choose to save your curve characteristic to employ on similar images.

6 Making use of droppers

As with levels, you can also make use of the droppers in curves. They can be valuable to make quick alterations, particularly for colour corrections on well-exposed images. With the **CURVES** dialogue box open you can select the first dropper on the left to sample a black point, and then with the other two droppers, the mid-tone grey and white points. This gives Photoshop a pure tone source to read from – a reference point to show how the rest of the colours should look.

7 Reference points

Here is the image after setting the points. I have indicated with arrows where I selected the samples from, to illustrate how to find points for droppers. The black point comes from the tree trunk, the grey point is taken from the fence post and the white point sampled from a portion of white cloud behind the tree. Good selections are key, otherwise the results can be garish and unnatural.

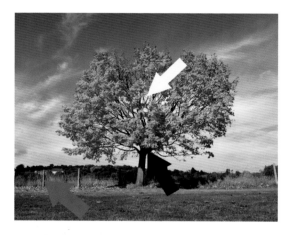

8 Adjusting the greens

So far all manipulations in curves have used the RGB channel. By selecting the channel modes at the top of the drop-down box you can choose one of the other channels in order to make precise colour correction. The image still has a slight yellow-green colour cast. So by choosing the **GREEN CHANNEL** I was able to make adjustments to the curve and improve the tone.

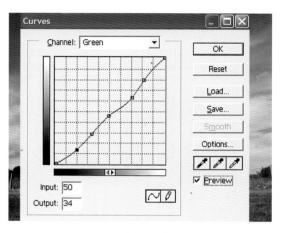

Hints and tips

When the curves dialogue box is open, if you move the cursor outside of the box the cursor arrow turns into an eyelet dropper. By clicking on areas in the image frame Photoshop will show you where that tone is represented on the curve. From here you can create an anchor point to make adjustments to the tonality of that specific area.

If you are not happy with your curves alterations at any time hit the **ALT** key and the option to reset the curve will appear below the **OK** button; click this once to return to the image as it originally was.

Curves can be used to make radical and extreme changes to an image. However, it is best to make very small, tentative alterations. One of the best techniques for clipping curves, when setting the black and white points, is to use the cursor arrow key, allowing for more delicate manipulation of the image.

Note that you can also draw a curve freehand with the pencil tool, shown at the bottom of the curves dialogue box. However, results with this tool can be very tricky to perfect.

9 Balancing the colours

The yellow and green casts in the image have been removed and the overall colour depth is better, bringing an almost polarized look to the image. The one down side is that while the highlight and shadow detail are good the mid-tone in the grass has turned a touch magenta.

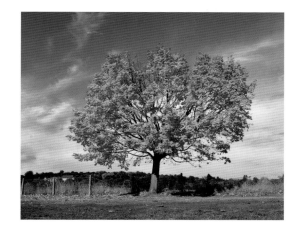

10 Adjusting the reds

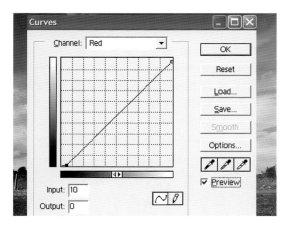

To fix the magenta cast I made one final colour correction by making a simple clipped curve through the **RED CHANNEL**. Dragging the shadow detail lightened the denser magenta areas and improved the foreground colour. To compensate I dragged the **HIGHLIGHT POINT** down to balance the exposure.

After
Here is the final image following the curves adjustments. In summary, curves is preferential for achieving very subtle changes. Here it has improved colour tonality, toned down highlights and made the sky a richer, more vivid blue.

Dodging and burning

In many ways Photoshop has been designed to mimic many of the different processes that are commonplace in traditional photography. Probably one of the most important arts in terms of working in the darkroom is that of **dodging and burning**, in other words adding or subtracting exposure to selected parts of the image.

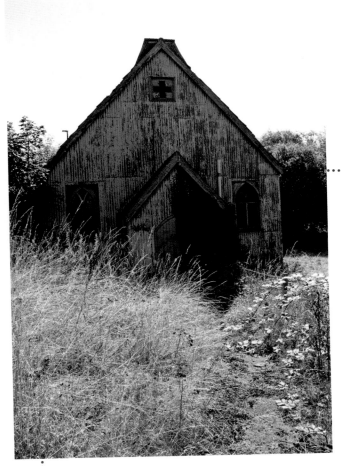

The great thing with digital photography is that you can now use digital manipulation to achieve traditional-looking effects without the paraphernalia of the darkroom. In fact it would be fair to say there is more control with dodging and burning in Photoshop than there was with traditional practices. In this section I will introduce the basics of how to use the dodge and burn tools in Photoshop.

Before

This image of an old chapel in Gloucestershire, England, is the perfect candidate for some dodging and burning. You can see that the exposure used has left the chapel itself too dark while the sky has started to bleach out. The mid-tones have also been reproduced a touch too light. Rather than try to use some of the exposure controls in Photoshop I will make use of dodge and burn techniques to quickly remedy these problems.

1 Hands-on burning

The first step is to engage the **BURN** tool which is found by pressing **O** or by selecting the burn tool through the Photoshop toolbox as shown.

2 The artist's brush

After selecting the burn tool the next step is to set up the size of the brush that you will use to do the burning-in with. In this case I wanted a fairly large brush so I went to the **BURN** toolbar at the top of the screen in Photoshop and clicked on the **SIZE** drop-down box in the top left-hand corner. I scrolled down and chose a soft-edged brush with a radius of 300 pixels. Once this is done you now need to set up how your burning in will react with the pixels in the image. You will see in the burning-in toolbar that there are the options to change the **RANGE** and the **EXPOSURE** of the burn tool (this also applies to the dodge tool). I would recommend that when you are burning in it's best to stick to using the highlights as the range, this means the lightest pixels are altered first, giving more controllable results. After this the most important thing is the exposure, 100% is far too strong, I usually recommend 10–30%. In this case I used 20% and then burned extra detail into the foreground of the image (the detail here is mostly mid-tone). I use light gradual sweeps which, with an exposure of 20%, were easy to build up naturally.

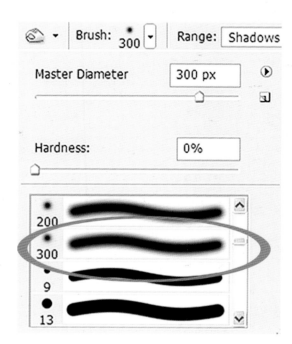

3 Darker in the foreground

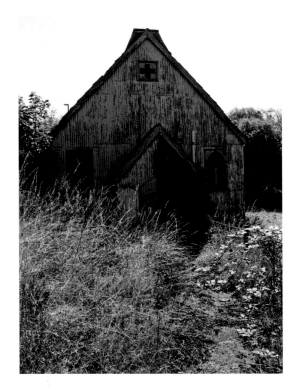

Here are the results after burning just the long grass in the foreground of the image. Already the balance of the image has changed, the extra detail added also affects the contrast of the image.

4 Time to dodge

Next it's time to use the **DODGE** tool, this is now accessed by going back to the **BURN** tool in the toolbar right clicking (or clicking and holding) the **BURN** icon which will then bring up some further options to use, including the **DODGE** tool. Once selected you can choose the brush and exposure – I used the same soft-edged brush with an exposure of 20%. Then I dodged over the whole chapel, using light strokes once again to pull back more detail into this area of the image.

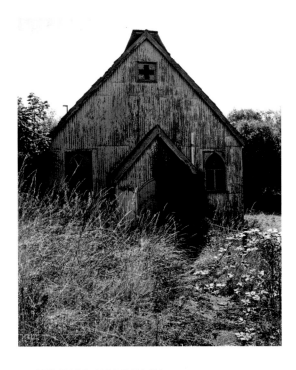

Pictured left is the image after dodging the chapel, now all that is left is to go back to the **BURN** tool again and use this to burn in the sky area of the image; I stuck with the same settings as before but this time I needed more strokes to try and increase pixel information in this area.

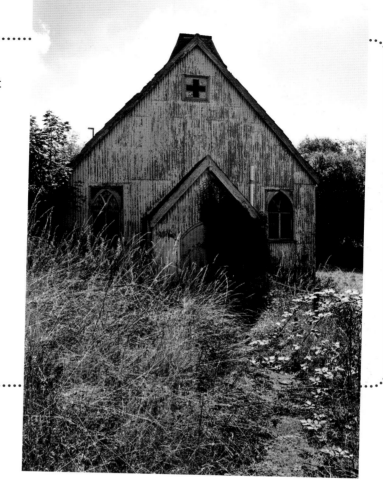

After

And here is the final result after using the dodge and burn tools in Photoshop. I have selectively worked on areas of the image just like I would have done in the traditional wet darkroom, holding back the chapel in the image while adding into the grass in the foreground and the sky in the background.

See also:

◀ Using levels, *page 42*

◀ Using curves, *page 51*

Hints and tips

It's worth noting that dodging and burning comes with a slight warning in Photoshop, in that pixels easily become 'bruised'. This is a reminder to use dodge and burn sparingly and remember it's not always possible to resurrect badly exposed images without affecting the overall quality, especially when it comes to printing.

If you're feeling a bit nervous about using the dodge and burn tools then you may want to do your dodge and burn work on a separate layer. Simply press **CTRL-J / CMD-J** to make a new layer then apply all the techniques as described here in that layer without touching the original. If it goes wrong you can always trash the layer, if it goes right simply flatten the layer and you have your finished image.

Underexposed images

Lots of people deliberately underexpose their digital images in order to avoid washed-out highlights. So here is a quick and easy solution for bringing an **underexposed image** back up to strength by using layers and a blending mode. Give this one a try as it's a really simple technique to have in your digital box of tricks.

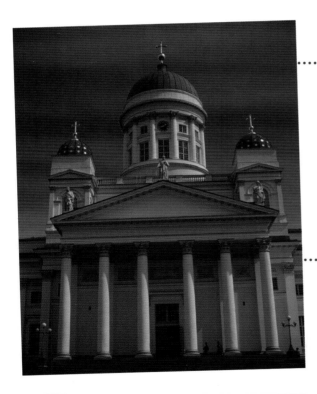

Before
Here is the starting image, a shot of Helsinki Cathedral, Finland. This picture comes from a transparency and was scanned at a photo laboratory; needless to say the results are far from impressive as the whole image has been left seriously underexposed by the scanning process.

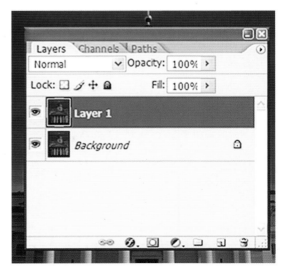

1 Create a new layer

To make a start on correcting the underexposure first open a new layer. The quickest way to do this is to press **CTRL-J/CMD-J**, this is the quick command to create a new layer. Once this is done you can see (by pressing **F7**) the new layer in the layers palette. You have a background layer and the layer you just created, in this case layer 1.

2 Watching the screen

Next, you want to change the blending option of the layer. Click on the drop-down menu that is set by default to **NORMAL** and select a new mode, that of **SCREEN**; this mode will lighten the whole image.

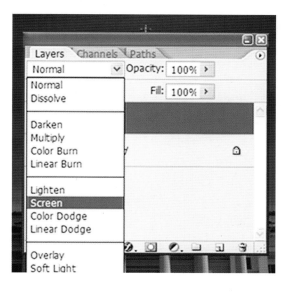

3 Quick and light

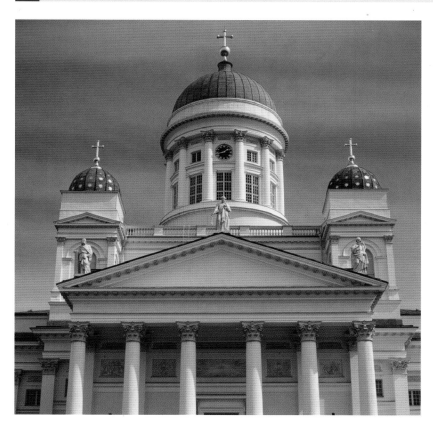

Now going back to look at the image, it has been given a quick boost, about one stop of extra exposure has been added making the image look lighter all round with much better tonality. However, the image is still a bit dark so it's time to repeat the process.

Underexposed images

4 Another layer on top

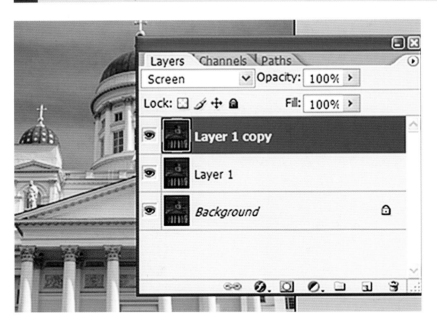

Now quite simply repeat the same steps as before. Create another new layer by pressing **CTRL-J/CMD-J**. As this new layer is created the image becomes yet lighter again.

5 Lighter and lighter

Take a look at the image now, it has really lightened up a treat. However, the exposure is now leaning towards being a touch overexposed; this is no great problem as you can easily take far greater control of the exposure to get the result spot on.

See also:

◀ Using levels, *page 42*
◀ Using curves, *page 51*
◀ Dodging and burning, *page 56*

Hints and tips

This really is a very simple way of lightening your image. It's not suitable for more complex images for which the levels and curves tools are the better, more precise options.

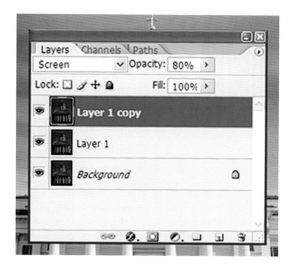

Going back to the layers palette (press **F7** to bring it up on screen), you can make use of the **OPACITY SLIDER** in the top right-hand corner, by clicking on the arrow next to the opacity box to make the slider appear. Adjust this – the image should offer you a live preview – until you get the effect you desire, in this case 80%. (Alternatively you can type in a value in this box.) This darkens the image and retains some of the highlight detail lost in the last step.

After
And here is the final corrected image. This technique can work a treat with images that are very underexposed and what's great is that it's a fast method to employ if you're in need of quick results.

Colour Made Easy

Colour management

Before considering working with images it's worth taking some time out to consider the idea of **colour management**. Good colour management is all about keeping colour consistent from one device to another – from the camera or scanner to the image-manipulation software, monitor and on to the printer.

All devices invariably have a different range of colour that they can produce, this is known as their colour gamut. The way we control these gamuts to achieve correct colour is the act of colour management. Things get more confusing when one device (a digital camera for example) uses an embedded profile that does not match

another device. So, to avoid problems it's worth taking time to set up Photoshop to work with you and not against you. This section outlines how to make use of colour settings so that you can get the best results from your digital images, while retaining a good level of consistency throughout the process.

See also:

▶ Hue and saturation, *page 70*

▶ Using threshold layers, *page 74*

▶ Calculated corrections, *page 80*

▶ Colour-correction filters, *page 85*

▶ Using the colour range, *page 88*

1 Setting the scene

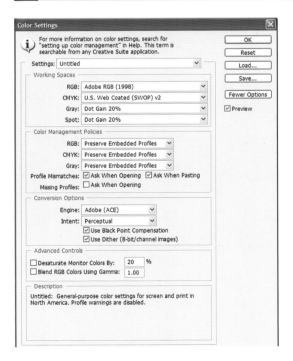

The first thing to do is open the colour settings dialogue box which is where you can decide how colour management issues are handled. Go to **EDIT → COLOR SETTINGS**, or **PHOTOSHOP → COLOR SETTINGS** on some Mac versions. Once this is chosen a dialogue box appears, click on **MORE OPTIONS** or **ADVANCED MODE** to display more information and the box will look something like the one shown on the left.

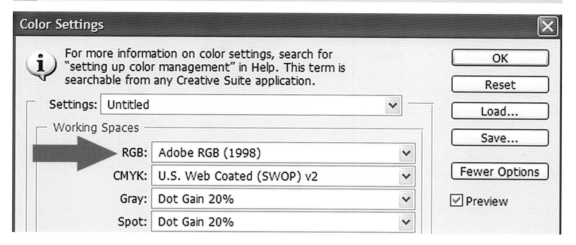

Now here comes one critical thing that I would recommend every serious digital photographer interested in printing to do. Most likely you will find that your colour working space for RGB is set as **SRGB IEC61966-2.1**. I can tell you now that this is probably one of the worst colour spaces to work in for digital photographs. It does, however, just happen to be the colour space that most consumer digital cameras shoot in. Change this setting to

ADOBE RBG (1998) which offers a much wider colour gamut and will yield much more useful results when dealing with colour images. After setting up the RGB space you will see there are some more drop-down box options. As many photographers will not have the need to work with CMYK (and you cannot access it in Elements) it's fine to leave this at the default. This is also true for the **GRAY** and **SPOT** settings at 20%.

3 The policy provider

Moving down the dialogue box you can check the status of the colour-management policies. For working with RGB, CMYK and Gray it is best to keep these all set to **PRESERVE EMBEDDED PROFILES** as this is the most appropriate and flexible option. After this you should set up the **PROFILE MISMATCHES**. Check **ASK WHEN OPENING** to make sure that Photoshop will inform you of an embedded profile mismatch and ask you how you wish to deal with this situation. Also check **ASK WHEN PASTING**, this will make sure Photoshop asks you how you want to deal with a copied image that you are pasting into another image. Leave the **MISSING PROFILES ASK WHEN OPENING** box unchecked, so the image will automatically convert to your chosen profile.

Colour management

4 Being converted

The last part that you need to be concerned about is the **CONVERSION OPTIONS** that Photoshop will use when converting from one colour space to another. In this case you should set the **ENGINE** drop-down box to **ADOBE (ACE)**, which is the best for converting photographic images. The **INTENT** needs to be reset to **PERCEPTUAL** for best working results. The **USE BLACK POINT COMPENSATION** box can be left checked, to make sure that the darkest information in the image is handled appropriately; if it was off then the darkest neutral colours would simply get mapped back to black leading to inferior colour balance. Lastly ensure the **USE DITHER** box is checked; this gives better blending of digital values when converting profiles.

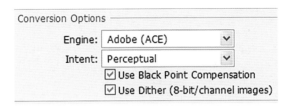

5 Comments please

Now that you have your settings appropriately set out it's worth saving them so that you have a master copy of them should you choose to change the settings at a later date. Click on **SAVE** in the **COLOR SETTINGS** dialogue box, Photoshop will automatically go to the settings folder, you can now give the file a name of your choice. Now when you name the settings and click **OK** a dialogue box will appear, as seen below. This box will allow you to place your own commentary on what exactly the nature of your profile is for. At this point you may wish to type over the default text to note that this is your main colour setting profile for dealing with your digital images.

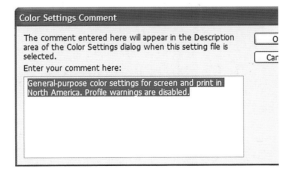

6 Sorting out the mismatch

Now it's worth noting that with this set-up whenever you open an image with an embedded colour profile that doesn't match your working space you will see the **EMBEDDED PROFILE MISMATCH** pop-up box, as below. The chances are you may have seen this before, as most consumer digital cameras, when working in jpeg format, will use the sRGB IEC61966-2.1 colour profile. As you have changed Photoshop to work in the Adobe RGB (1998) colour space (with its wider colour gamut), Photoshop will now prompt you that there is a discrepancy between the source file and destination colour space. When this occurs the best option is usually to click on **CONVERT DOCUMENT'S COLORS TO THE WORKING SPACE**. This means that Photoshop will now convert the file to Adobe RGB (1998) giving you the optimum colour space to work in with your file.

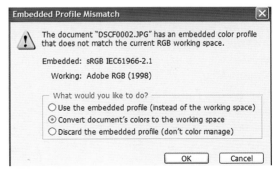

Colour management

7 Save the profile

Whenever you save an image make sure that the **ICC PROFILE** check box at the bottom of the page in the **SAVE AS** dialogue box is checked. As we have converted the file from one profile to another this will make sure that our file is kept as the preferred Adobe RGB (1998) colour space format.

 With this simple set up in place you have now gone one step towards taking more control of colour management.

Hints and tips

At the start of this tutorial you changed the colour space to Adobe RGB (1998). It's worth noting that you can actually view the physical change of colour spaces if you open up a file while you are working with colour settings; simply change the RGB working space and click on and off the preview tab, when you do this you can see the image colour change from the default sRGB IEC61966-2.1 to the colour space of your preference.

The Elements colour-management options are simpler, but you should still take the time to choose whether the images should be optimized for display or printing, or left to your discretion.

If you want to know a bit more about the settings that are described in this tutorial simply try hovering your cursor over the different boxes in the colour settings dialogue box. This brings up clear explanations of what effect each setting has on your images.

If you change your colour settings it's always worth saving them, this way you can reload an old profile at a later date. To load a profile simply click on the **LOAD** button in the colour settings dialogue box.

Hue and saturation

One key command that you may want to put to use when dealing with colour in your images is the **hue and saturation** function.

This tool allows you to take control of colour by by being able to specifically alter saturation and, as the name suggests, being able to make subtle changes in the hue. The function also allows you to alter the lightness of the image at the same time if you wish. The hue and saturation tool works like a colour wheel, as you alter the hue with the hue and saturation slider, either going

to the left or right, the colours in the image will eventually reach their opposite colour in the spectrum. For example, magenta will become cyan (try this out when you are using this function and you can see it for yourself). However, when we work with this function we tend to work with just creating slight, subtle shifts and not such great changes.

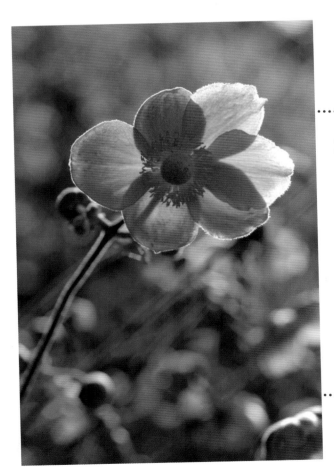

Before
This image of a Japanese anemone has far too much of a magenta cast, using the principle of the hue and saturation colour wheel I wanted to create a new colour balance by adding more blue and green hues to the image.

1 Selecting the hue and saturation tool

To select the hue and saturation tool simply select **IMAGE →**
ADJUSTMENTS →
HUE/SATURATION or
ENHANCE → ADJUST
COLOUR → ADJUST
HUE/SATURATION in
Elements. Alternatively use the **CTRL-U/CMD-U** key press.

2 The hue and saturation dialogue box

The **HUE/SATURATION** dialogue box shows you three sliders that control the **HUE,** the **SATURATION** and the **LIGHTNESS**.

Hue and saturation

3 Mellow yellow

If there is a specific problem with your image it is best to choose a specific **EDIT** mode, in this case **YELLOWS**. Change the hue, saturation and lightness using the sliders. In this image the saturation and lightness were fine so I just tweaked the hue to +15, adding more green for a more natural effect. You can work through any of the individual colours to add or eliminate that particular colour and improve your image.

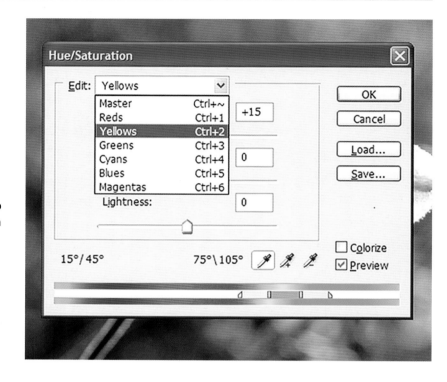

4 Working with the master channel

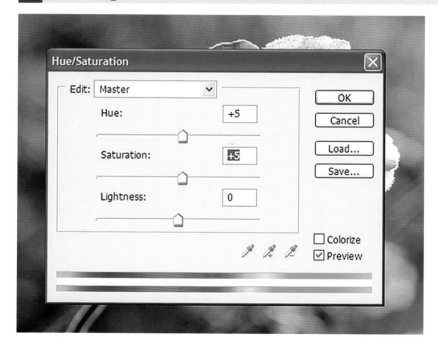

Now you can go back to the master channel. This allows you to make alterations to the overall balance of saturation, hue and lightness. In this case I reduced the overall magenta cast in the image by shifting the hue to +5, and slightly boosted the saturation to +5, to give more vivid colours. The overall exposure is fine so I didn't touch the lightness slider. Once finished, click **OK** and return to the image.

Hints and tips

It is well worth using the hue and saturation function as an adjustment layer. This means that you create the effects on a separate layer that you can come back to and change again before finalizing the manipulations on your image. To create a hue and saturation adjustment layer simply select **LAYER → NEW ADJUSTMENT LAYER → HUE/SATURATION**, or choose this command from the layers palette by clicking on the **CREATE NEW FILL OR ADJUSTMENT LAYER** icon at the bottom of the box. When you are finished with your layer remember to flatten the image by selecting **LAYER → FLATTEN IMAGE**.

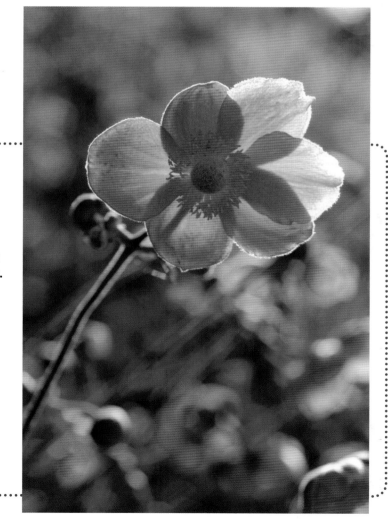

After

And here is the final image. Using the hue and saturation tool I have carefully corrected the magenta cast, replacing it with more green and cyan. This has helped to create a better-balanced and more natural image.

Using threshold layers

One way to colour correct the tonality of an image is to use the droppers in the curves function, but you can enhance this by using a **threshold layer** to find the black and white points.

As is the case with levels, curves has three droppers that can be used to set the black, mid-tone and highlight points. However, I always find that with the curves setting these droppers are rather awkward. To resolve this problem there is one excellent method which can assist

you in finding the black and white point, and this is by using a threshold layer which allows you to seek out the black and white points in the image. Once these are located you can then use the droppers in curves with ease and confidence to correct the image.

Before
My starting image was a field of poppies, the colour balance was out. So, to start with I worked with the eyedropper tool and threshold layers to find the darkest part of the image.

1 Knowing the threshold

To make a threshold layer go to the layers palette by pressing **F7** or selecting **WINDOW → LAYERS**. At the bottom of the **LAYERS** pop-up box there are a number of icons. Click on the one in the middle, which is a half-black half-white circle, this is the **CREATE NEW FILL OR ADJUSTMENT LAYER** icon and will open a drop-down box. Click on the **THRESHOLD** option; once you do this your image turns into a rather bizarre high-contrast monochromatic graphic representation.

2 Finding the black point

The **THRESHOLD** dialogue box will appear as shown. The slider at the bottom helps you find where the different tones are. If you move the slider to the left the image becomes more and more white – at some point there will only be a tiny amount of black left (sometimes a small group of dots), this represents the very darkest ones in the image. When you have the smallest visible area click **OK**.

3 Target marker one

Going back to the image in its present state you now want to make a visual reference to this black point in the image. In this case you can use the eyedropper colour sampler tool. Press **I** or simply click on the **EYEDROPPER** icon to engage this function. If you click and hold on the **EYEDROPPER** icon you will get more tool selections, choose the **COLOR SAMPLER** tool. Now all you have to do is go to your image and click on the little black dot that is left on the image from the threshold layer. A visual target point is created which you can use later.

Using threshold layers

4 Finding the white point

Now you can use the same method to find the highlight point in the image. To do this you need to create another threshold layer. To get this right make sure that you go into the layers palette and click on the background layer at the bottom. Once this is done just create another threshold layer by clicking on the **CREATE NEW OR FILL ADJUSTMENT LAYER** icon (the half-black and half-white circle symbol at the bottom). This time when the **THRESHOLD LAYER** dialogue box appears simply move the slider all the way to the far right-hand side until a small area of white remains in the image, this will represent the lightest highlight in the image, once this is done click **OK**. Now you can use the colour sample tool again to make a reference point for the lightest point on the image, simply hover the mouse on the white area and click to make your tag.

5 Threshold to the trash

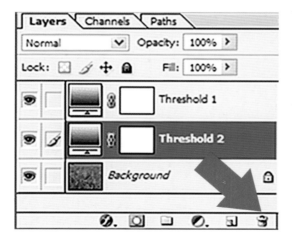

Now your work with threshold layers is done, you need to go back to the layers palette and delete the threshold layers. The quickest way to do this is to simply click on each threshold layer one at a time and drag them into the **TRASH CAN** at the bottom right-hand corner of the window.

Hints and tips

If you're feeling confident and can find a good grey mid-tone in the image then incorporate the mid-tone dropper into this technique as well to get the perfect balance.

Don't forget to clear your target eyedropper markers after working on an image in this way. Just click on **CLEAR** in the **EYEDROPPER** toolbar at the top.

Unfortunately, you cannot use the curves function in Elements so this tutorial is of limited use. However, you can still use a threshold layer to find the darkest and lightest points, take a note of the references and utilize these in the levels function.

6 Finding your markers

Now it's time to focus on the two tag points you made previously. Zoom in a little on the two points using the zoom tool (**Z**) to make sure you have them clearly in view. Then, the next step is to open curves, **IMAGE → ADJUSTMENTS → CURVES**.

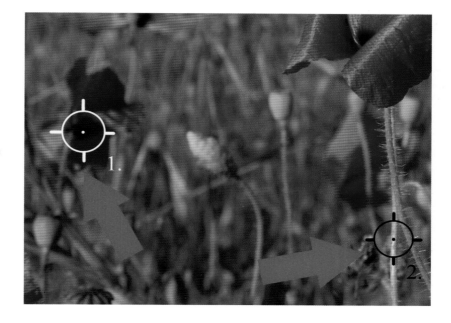

7 Using the droppers

Inside curves there are the three droppers that you are already familiar with, which are used for referencing the highlight, mid-tone and shadow points. Now if you click on the first dropper on the left you can work at setting the shadow (black) point in the image. Simply go into the image and click on the area of the first eyedropper target marker, this is referencing the darkest part of the image.

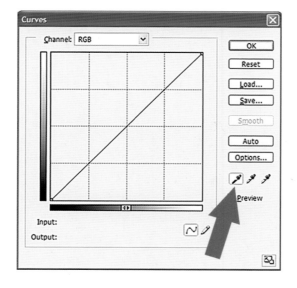

See also:

◀ Using curves, *page 51*

◀ Using droppers, *page 46*

▶ Calculated corrections, *page 80*

8 Changing colours

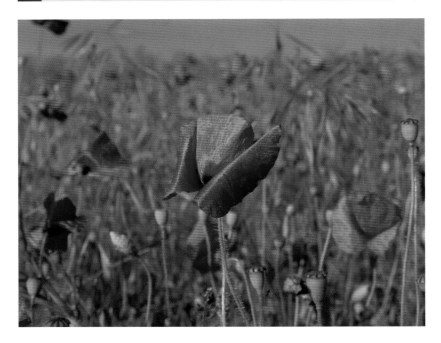

Here are the results from the previous step. The colours have changed and already the tonality of the image has improved.

9 Setting the highlight dropper

The next step is to repeat the same process using the **HIGHLIGHT DROPPER**. Click on the right-hand dropper and then go to the image and click the mouse on the second target marker for the white point. Again the image's tonality alters, the highlights clean up and the contrast should improve.

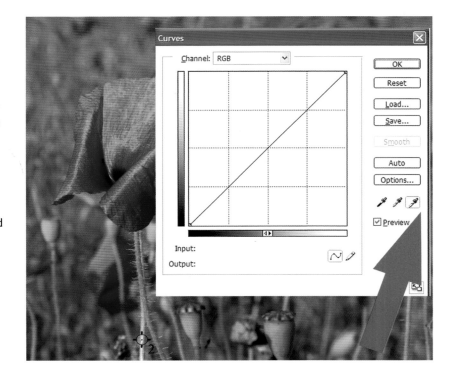

The last thing to do, which is often a good idea, is to just make a small alteration to the curve itself, in this case by making a small adjustment to the centre of the curve line. In this case dragging it up slightly has improved the exposure of the mid-tones. Once you are happy click **OK**.

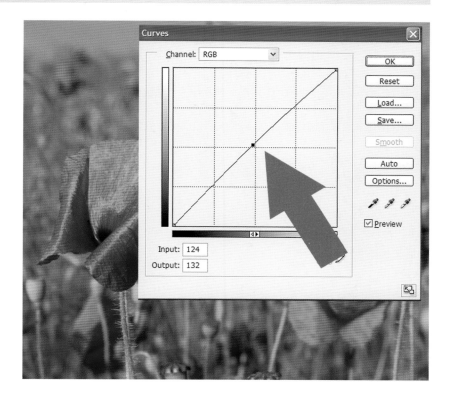

After

And here is the final image. This method may seem a bit lengthy but once you're used to it you can perform it quickly and easily. It allows you to make much better judgements on where the droppers should be used in the image and increases colour and exposure accuracy.

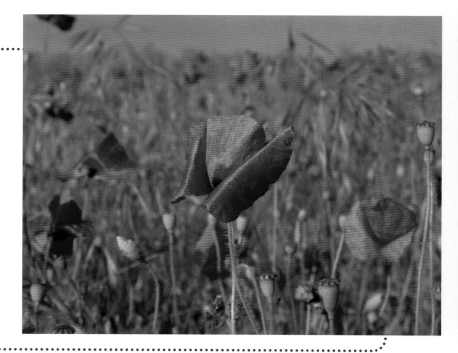

Calculated corrections

When you're having no luck with colour correction sometimes it helps to take a more advanced approach, such as **calculated corrections**, this may sound a bit daunting, but careful practice will soon show you that there is always a solution to correcting tricky images.

In this case I will use an image of the Albert Memorial in London taken on a very cloudy day where the auto white balance of the camera has rendered the overall tonality very cold, with an overall blue cast.

Before

Here is the starting image; the big thing to address is that the tonality and contrast are not right. The colours appear to be lacklustre when my memory says that the original scene was anything but. So, in order to get this rectified I colour corrected the image using the incredibly useful calculated correction method.

1 Finding the navigator

First select the **COLOUR SAMPLER** tool which is located by clicking and holding the **EYEDROPPER** tool. To get this process to work there are a few things you need to set up correctly. The first is the sample size of the **EYEDROPPER** tool. In the top left of the screen you will see the **EYEDROPPER** toolbar. There is a drop-down box which allows you to change the selection size from **POINT SAMPLE** to **3 X 3 AVERAGE** or **5 X 5 AVERAGE** (the number of pixels that will be sampled from to give an average reading). In this case I selected **3 X 3 AVERAGE** from the drop-down box. The next tool you need to access is the **NAVIGATOR** pop-up box which, if not already there, can be brought up on screen by selecting **WINDOW → NAVIGATOR**. Elements users will be restricted to noting down the values rather than using the colour sampler, so simply select the eyedropper and click **WINDOW → INFO** (this is actually the location of the **INFO** palette for some full Photoshop versions anyway.

2 Check out the info

Once the navigator is open click on the **INFO** tab as it's here you will find the information you need to get the right selection with your eyedropper. As you glide your eyedropper tool across the image you can see the colour value of the pixels changing in the info palette.

Calculated corrections

3 Info on greyscale

Now you want to find a value that is purely greyscale, and to do this you need to change the set up of the info palette. All you need to do is click on the **EYEDROPPER** tool on the top left-hand side of the info palette, when you do this you can choose to change to other colour schemes; then choose **GRAYSCALE**. Now the RGB values are removed with just a K value which represents tones from 0–100%, starting at white and going through to black. Try to find a group of pixels between 10–20% which will represent a tonal area of pixels that are highlights which contain some detail within them. If you hover the eyedropper tool over a highlight patch you can watch the K value change in the **INFO** palette. I found a suitable area which represents a K value of 20% and clicked on it to make a **COLOUR SAMPLE** point to use later. Elements users will have to take a note of the references at this point.

4 Levelling up

Now you need to jump straight to the **LEVELS** command, **IMAGE →
ADJUSTMENTS →
LEVELS** or **ENHANCE →
ADJUST LIGHTING →
LEVELS**. From here you want to be able to access the **COLOUR PICKER**. Place the cursor over the highlight dropper in levels (the eyedropper to the far right at the bottom) and then double click it in order to bring up the **COLOUR PICKER**.

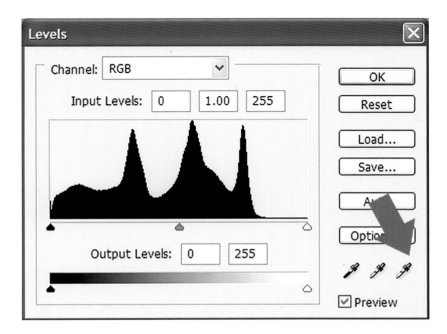

PHOTOSHOP MADE EASY

Hints and tips

Don't forget there are other Photoshop colour correction techniques which include the following:

LEVELS colour correction. In levels you will find that you can alter individual colour channels of an image and not just the RGB channel. Experimenting with working in the red, green and blue channels can yield good results for fine control of individual colour tones within the image.

Another option is using colour balance, **IMAGE → ADJUSTMENTS → COLOR BALANCE**, in this function you can selectively alter the colour in different colour channels but you also have the added function of being able to choose to control the shadow, mid-tone and highlight details individually. Great care needs to be taken as alterations can easily put the image out of balance.

REPLACE COLOUR is an interesting tool, if you have a colour of a certain tone you want to alter selectively you can do so with this tool. Select the **IMAGE → ADJUSTMENTS → REPLACE COLOR** or **ENHANCE → ADJUST COLOR → REPLACE COLOR** function then use the eyedropper to select the area of colour tone you wish to change. Once selected, simply alter the colour using the sliders and the various colour channels on offer. This function can be good for altering colour casts created when there are several different light sources in one image.

5 New colour values

Once the **COLOUR PICKER** is on the screen you can make your selection using the reference point (or the reference coordinates) you made previously. Simply hover the colour picker eyedropper over the selected point you created earlier and then click on it. When you do this you can see that in the colour picker one of the values has changed. The values you are concerned with are those of the **a** and **b** values. After selecting my point these values changed to −7 and −5 as seen above. Change the values of **a** and **b** back to **0**. Photoshop will now tag the value of your selected group of pixels to be white when you go on to select the highlight dropper in levels. Elements doesn't offer the **a** and **b** values so instead take a note of the different R, G and B values and key those in to the input levels for the separate channels in the levels dialogue box.

Calculated corrections

6 Correcting the colour

You have finally reached the point where you can colour correct this image. All you have to do now is to put the highlight dropper into action. Click on the highlight dropper (last on the right) and then move it onto the image in the screen so that you can click on the sample point you created earlier. Once you click on this point the colour of the image is quickly corrected.

See also:

◄ Using levels, *page 42*

◄ Using droppers, *page 46*

After

Using the standard method of droppers in levels would have been very hit and miss in an image like this but using the calculated method has been very successful, by designating a group of white pixels with detail to be the new standard of white. Using a precise colour correction method with a calculation has really given fantastic tonality and improved dynamic range to the image.

Colour-correction filters

One of the latest additions to Photoshop is the photo filter function. This allows you to recreate the effects that were previously achieved using **colour-correction filters** in traditional photography.

In the past the effects of these filters had to be created using multiple layers but the photo filter function allows you to perform this action without any lengthy procedures with layers, thereby cutting down on time, making it simpler and easier to enhance your images.

Before
As with many digital images taken on a bright sunny day, the colour balance of this image is a little cool. Many people, myself included, often forget to set a specific white balance when shooting, or are disappointed by the auto white balance results, but this can be quickly fixed with the photo filter function.

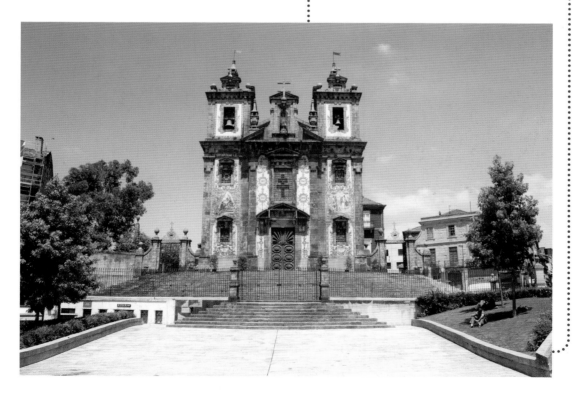

Colour-correction filters

1 Putting on the photo filter

To access the photo filter function you need to choose **IMAGE →
ADJUSTMENTS →
PHOTO FILTER** or in Elements **FILTER →
ADJUSTMENTS →
PHOTO FILTER**

2 Choosing the filter

A dialogue box now appears. From here you can choose many different filters, replicating colour-correction filters as used in film photography. In this case the default filter was the warming filter (85) which was just perfect for correcting the image I was working with.

Hints and tips

As well as the warm-up filters in Photoshop there are cooler options as well. If you have an image that has an unpleasantly yellow, warm cast then try using one of the cooling filters such as the cooling filter 80 or 82.

There are other filters available including sepia and a range of different special-effect filters.

It's worth noting that the **PHOTO FILTER** command can also be applied as a layer, simply go to the layers palette (**F7**) and choose photo filter by clicking on the **CREATE FILL AND ADJUSTMENT LAYER** icon.

A great feature with these filters is that you can control the density of the filter using the **DENSITY** slider at the bottom. In this case I increased the filter's power by sliding the density up to 40%, which returned a better result for this image. Keep **PRESERVE LUMINOSITY** checked, to make sure that the colour changes in the image without affecting the brightness.

After

And here is the final result, the cool cast in the image is taken out, giving a nice warm feel to it. This is a much more accurate representation of how the scene looked when the shot was taken, and a better memento of a lovely, hot, sunny holiday!

Using the colour range

Often in photography you are faced with an image that somehow just doesn't do justice to the original scene. Partly this is due to the way that both digital and film cameras simply cannot record the latitude of tones that we see with the naked eye; but making use of the **colour range** tool can correct this.

Camera meters do their best to balance out highlights and shadows to give an average exposure, and while they are sophisticated we are often left with a compromise between the highlights and shadows that can create a flat, lacklustre image. In this section we will explore the function of colour range using this tool's capability to enhance specific areas of the image and bring back that original eyecatching contrast and colour. You can use Photoshop to seek out similar tones and create selections in order to perform precise manipulations. By turning these selected areas into layers you can gain greater control and make use of the various different layer-blending options. Unfortunately the colour range tool is not available in Elements.

Before
This image comes from a digital SLR and you can see that the blue sky lacks real punch, while the detail in the shadow areas of the statue are all but a mere memory, after the camera's metering has done it's balancing job between highlight and shadow areas. However, with some simple work using the colour range I wanted to restore some robust tones.

1 Down to the fuzziness

The first thing to do is to open up the colour range function by choosing **SELECT → COLOR RANGE** from the top toolbar. The colour range dialogue box appears on the screen, and in this case I wanted to tell Photoshop to select the area of blue sky in the image. The simplest way to do this is to make a colour selection using the eyedropper tool. By clicking on the **LEFT EYEDROPPER** and then making a selection by clicking again on a blue-toned area above the statue's head Photoshop created a selection of all similar blue tones within the image. The **FUZZINESS** setting is critical, it dictates how close you want the selection to be to the chosen colour tone. In this case a fuzziness of 70 works well, seeking out the mid-tone blues. Clicking **OK** will then show the selected area.

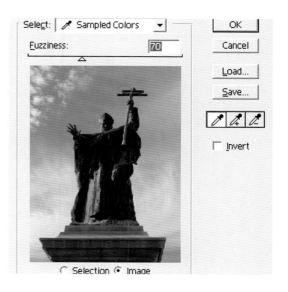

2 Making a new layer

You can now work directly with the selected area or alternatively you can create a layer for more flexibility, the latter is the best option. Choosing **EDIT → COPY** and then **EDIT → PASTE** creates a duplicate layer of the selected area. Going to the layers window you can now see two layers: the background image and the selected area. The next step, for this image, was that I wanted to increase the density of the blue in the sky by opening the hue and saturation tool, **IMAGE → ADJUST → HUE /SATURATION**.

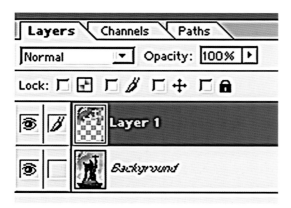

3 A bit of hue and saturation

With the hue and saturation tool open you can work by changing the colour within the selected area by choosing just to work within this layer. This is an excellent way of adding colour into any images with overcast skies that need a touch more zest. In this case altering the hue to +30 gives the sky a denser feel, any more and the image would have a magenta cast. Adjusting the saturation by +12 increased the vibrancy of the colour, while choosing −7 with the lightness slider allowed me to darken the whole selection for a richer effect.

4 Blue skies are here again

The image already looks more bold and dynamic; with this layer left open you can always come back later to make any more tweaks using other tools for a great final result. The next step is to make use of the colour range tool again, this time to seek out the shadows within the image, mainly the dense patches of shadow within the statue.

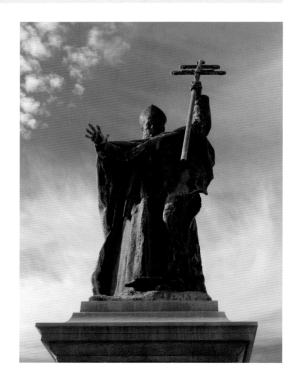

5 Seeking out the shadows

Choosing **SELECT → COLOR RANGE** again, this time you can instruct Photoshop to make a selection based on all of the shadow areas in the image, with the aim of acquiring a selection of the densest shadows within it. Clicking on **SAMPLED COLORS** activates an extensive drop-down menu. In this case I chose the **SHADOW** command. By clicking **OK** the colour range will make a precise selection of dark areas within the image. At this point make sure you click on the background image in the layers palette; then choose **EDIT → COPY** and **EDIT → PASTE** to create a new layer of this selected area which will appear in the layers window.

6 Premiere screening

Going into the layers window you can make use of a number of layer blending options to lighten the selected shadow area. Clicking at the top left on **NORMAL** opens a drop-down menu with a range of options for blending the layer in with the background image. You can choose from **COLOUR DODGE** to lighten, but in this case for best results I made use of the **SCREEN** blending option.

7 Making things transparent

The result of using this blend option is similar to a fill-in flash effect. Personally I find it a little unnatural so the simplest thing to do is to make use of the **OPACITY** slider in the levels window. Clicking on the arrow to the right of opacity you can alter the blending ratio with the background image, in this case to 65%, for a more subtle and natural image.

8 Striking the balance

Now the image has a strong, vibrant blue sky with effective lightening in the shadow areas. One final issue to address is the highlight areas of the white clouds, there is already some detail in there that can be pulled back even more by making use of a colour selection to pick out the highlight detail.

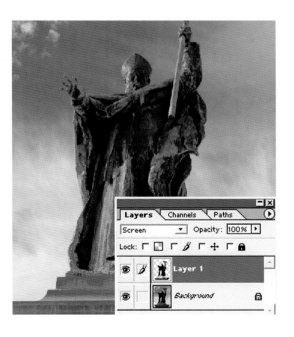

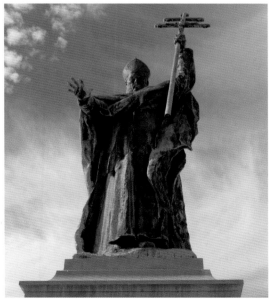

Hints and tips

Note that while colour range can make a selection of a desired area, you can also invert this area in the colour range dialogue box so that the selection is reversed to outside that of the marquee line, this provides yet another tool and technique for selecting areas of your choice.

Remember the range of options with colour range is broad: try making use of the mid-tone selection area or even the individual colours such as red, green and yellow to make specific selections of your choice. All these selections are available by clicking on the **SAMPLED COLORS** box within colour range.

Remember colour range can be used as an alternative to the magic wand tool in an image where you find yourself in a tight spot. If, for example, you want to select a complex area, let's say the lines of a gate or a fence, in which you want to do some manipulation work. If the area is of a similar colour you may match the tone of the subject with the colour range picker to make a selection by colour tonal range. Just use the fuzziness slider to control how far and wide your selection area will become for accuracy.

Note that the + and – eyedroppers in the color range dialogue box can also be used to add or subtract from the selection that you have chosen.

9 Show me the highlights

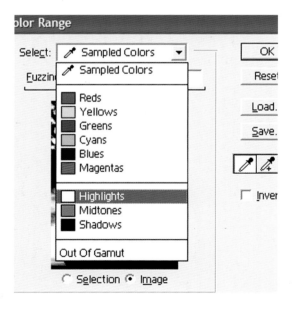

By bringing up the colour range function one last time and clicking on **SAMPLED COLORS**, you can instruct Photoshop to seek out all of the highlight areas in the image. Once you click **OK** Photoshop sets to work making a selection of the white cloud areas. Go to the layers palette and click on the background, then copy the image **EDIT → COPY** and then paste it as a layer **EDIT → PASTE**. You can now work at bringing back some subtle detail into the highlight areas.

10 Go forth and multiply

Going back to the layers window, this time I chose to use another blending tool; by clicking on **NORMAL** I chose the **MULTIPLY** option, which in effect multiplies the detail within the selected area. Leaving the opacity at 100% makes for some unnatural results: with some simple manipulation of the **OPACITY** slider you can reduce the multiplication to render a far more pleasing image. In this case I decided to pull the **OPACITY** slider down to just 35% to add subtle detail into the clouds.

See also:

◀ Dodging and burning, *page 56*

◀ Using droppers, *page 46*

▶ Altering highlights, *page 96*

After

The final image is a testament to the power of the colour range function. In this case I have made some simple alterations to produce a far more visually effective result compared to my original digital image. The great benefit is that of speed and convenience by being able to make quick selections of target areas according to tonal values. Also by using layer blending options you can produce results which can sometimes be superior to lengthy dodging and burning. At this point you can flatten the image, or save it as a PSD file, which will keep layers intact for further manipulation of at a later date.

[5]

Selecting & Retouching Made Easy

Altering highlights

In this example you will see how you can load just the **highlights** of an image into a selection that, when combined with a layer, can be altered to fine-tune and create just the right style of contrast for the image.

The highlight areas of a digitally captured image can be particularly problematic because of the nature of digital sensors so here is a quick and easy way of retouching them. Despite the lack of *a specific select highlights function in Elements you can still follow this tutorial, albeit with a little less ease, by carefully using the magic wand tool.*

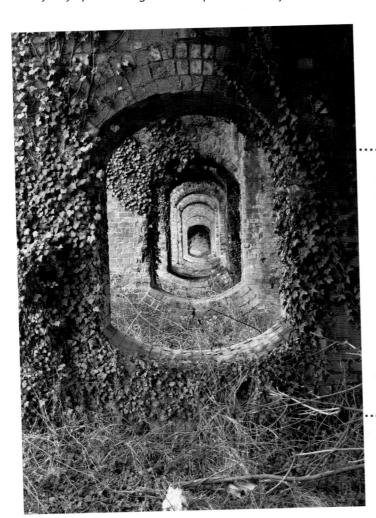

Before
Here is the starting image, looking through the arches underneath an old disused railway bridge. The image is quite dark overall and to create a more distinct differential you can use the method of selectively altering the highlights to create a vastly improved result.

1 Preparing a new layer

The first thing to do is to create a new layer, simply press **CTRL-J** (**CMD-J** on a Mac) this layer will give you the control you need as you use the blending options on the selected area.

2 Selecting the highlights

Now you need to load all the highlights in the image into a selection. To do this simply press **ALT-CTRL** and ` (for Mac **OPTION-CMD** and `). If you are wondering where to find the ` symbol, this is the tilde key which is just above the tab key on the keyboard. When you do this all of the highlights in the image will be loaded into a selection. In Elements select the magic wand tool (**W**) and click on the **NEW SELECTION** icon in the magic wand toolbar, then click on a highlight. If this does not select everything that you wish, alter the tolerance or choose the **ADD TO SELECTION** icon and click on other areas. Then copy **EDIT → COPY** and paste the selection **EDIT → PASTE** into the new layer.

3 Using the screen

Now you can go back to the layers palette (**F7**). You need to change the **BLENDING** option from **NORMAL** to **SCREEN**. Simply click on the drop-down arrow and choose the **SCREEN** option from the menu.

4 Lowering the opacity

Using the **SCREEN** option at an opacity of 100% will make the image way too bright; in order to remedy this you can simply use the **OPACITY** slider and reduce the amount to 50%, halving the intensity and making the image much more balanced.

After

And here is the final image; the highlights have been selectively lightened using this technique. It shows how you can make a selection very simply and alter that selection with a layer to gain subtle and simple control over the image.

Hints and tips

The purpose of this tutorial was to show how you can make a selection of the highlights but there is no reason at all why you can't turn all this on its head and invert the selection to just have the shadows as your selected part of the image. Press **W** to engage the **MAGIC WAND** tool then right click (**CTRL** - click for Macs) and choose **SELECT INVERSE** from the drop-down menu that will appear at that point. You can then selectively just alter the shadow detail away from the mid-tone and highlight details.

Using the healing brush

The **healing brush** tool is fairly new to Photoshop, but one really has to sing its praises as it is simply quite miraculous. Not only are the effects very impressive, but it is one of the easiest tools to get to grips with.

The healing brush allows you to repair or cover up areas of pixels in the image. In some ways it works similarly to the clone tool, you still use a reference point to match one part of the image to the other. The big difference however is that the healing brush blends in the reference point with

the original pixels which are lying underneath. It allows for more subtle results than the clone tool creating a more natural result. In this tutorial you will be shown how to put the healing brush tool to use on a portrait, but it can be used for many other subjects.

Before
Nobody is perfect, we all suffer from the odd sleepless night from time to time which can leave us with tired eyes. In this example I wanted to use the healing brush tool to wash away the bags under the eyes and any wrinkles as well as to remove the red blemish on the subject's chin.

1 Selecting the healing brush tool

To select the healing brush you need to go to the Photoshop toolbox and click on the sticking plaster icon, or press short-cut key **J**.

2 Creating the brush size

The next thing to do is to set up the brush for the healing tool. Click on the drop-down arrow next to brush in the toolbar and then you can change the diameter of your brush. All the other settings can be left as the default. In Elements the brush size and shape are selected from the toolbar independently.

Jargon Buster:

Pen pressure

Some retouching tools within Photoshop allow you to select activate **PEN PRESSURE**. This is a useful tool that enables Photoshop to recognize different pressures placed on a compatible graphics tablet, and is a very simple way of varying the effect of a tool.

3 Sourcing a reference point

Now it's time to get to work on the image, you need to source a group of pixels which Photoshop will use as a reference point to heal over any pixels. In this case I held down the **ALT** key and then clicked on an area of pixels just below bags under the eyes where the skin is smooth and of the desired colour. Once done you can let go of the **ALT** key.

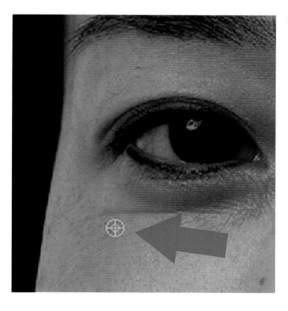

Hints and tips

For tiny blemishes the spot healing brush, which can be selected from the healing brush toolbar in Elements, is more appropriate.

You can select different blending modes in the healing brush toolbar to determine how the new pixels blend with the existing ones underneath them. Experiment with different settings for different effects.

Even though the healing brush is a very clever tool you should take care to select the right brush shape and size. This is particularly important when you are dealing with hard-edged subjects, where you should try to align the edge of the brush with the contrast on the image.

Now you can use the tool to start to paint away the bags. I simply painted under the eye in one smooth stroke, at first the alteration looks hideous but after a few seconds this will transform and the pixels look nicely blended in. In fact you can build up the effect and in this case I have used three strokes of the healing brush tool to get the effect I wanted. Take a look at the image to the left, you can see I have completed the left eye but not the right.

Using the healing brush

See also:

▶ Using the clone tool,
page 104

After

After moving on to the right eye I repeated the process for the red spot on the chin, again taking a reference point from an area just to the side of the red mark and brushing over it with three or four sweeps of the brush. I also used levels to improve the overall exposure (see page 42) and now the image makes my subject look completely fresh-faced and revived.

Using the clone tool

While the healing brush can work miracles, some older versions of Photoshop don't have it so you may have to rely on the **clone tool**.

Retouching images has always been part of the traditional photographic process, although in the past it tended to be the humble dust spot that was of most concern. Now with the advent of digital photography it's almost taken as a given that we can use Photoshop to improve portraits by trying to make our subject look more appealing in the final image. This tutorial demonstrates just how the clone tool can be used quickly and effectively to remove small blemishes on the skin of a portrait subject. This is a great technique for portraits and it also illustrates how you can put the clone tool to work for you. The clone tool basically does what it says, it clones one part of the image to be transferred to another and while not as advanced as the healing tool it is a great option for retouching and covering up parts of the image.

Before
This studio image has worked nicely with well-balanced lighting. But to round the image off I'm going to take out some of the small moles and freckles that can be found in the image to give smooth, flawless-looking skin.

1 Setting to clone

To engage the clone tool simply click on the **CLONE** tool icon or press the short-cut key **S**. With the clone tool selected the next thing you need to do is select an appropriate brush. This is done by clicking on the drop-down menu at the top of the screen. From here use the **MASTER DIAMETER** or **SIZE** slider at the top to specify the correct size to work with. After this the next alteration you need to make is to set the clone tool **MODE** to **LIGHTEN**. This will mean that when you perform cloning the cloning will only work on dark pixels in the image in order to lighten the area up.

See also:

◀ Using the healing brush, page 100

Hints and tips

🖱 Sometimes the flaws in the skin may not always be as dark as a mole for example and to get more subtle results, such as with red coloured skin blemishes, it can be worth setting the opacity of the clone tool to a lower value, between 60–80%, to gain more control and natural results in your retouching work.

2 Seeking out the spots

Simply scan across the image looking for any blemishes to remove. When you find one use the zoom tool to take a closer look at that area of pixels (press **Z** to use the zoom tool and then click to zoom in). In this case I found a small mole on the bridge of the nose which was the first one that I removed. To use the clone tool, start by selecting an area of pixels as a source to copy from. This is done by pressing **ALT**, at this point a target finder symbol will appear, if you click anywhere in the image with this target finder that area will be set as the source area. In this case I selected an area just above the mole in the image, and clicked to make this my target reference point.

Using the clone tool

3 One click solution

When you let go of the **ALT** key you basically have a paintbrush to work with, a brush appears, the size and shape of which was dictated earlier. All you need to do now is simply click once over the blemish to remove it. As you can see the mole has gone and a perfect cover up has been achieved.

After

Using the clone tool, I moved across the image and removed all of the other obvious moles and marks, giving a flawless finish to the skin. The final result can be seen here with a much smoother complexion.

Quick mask

One way to make a very quick selection of an area to apply changes to is
to use the **quick mask** function.

*Quick mask allows you to paint an area over the
image, which can be instantly turned into a
selection. This is convenient as you can then use
that selected area to make individual changes.*

*This tutorial demonstrates how to use the quick
mask function to sharpen certain areas within
this flower image. Unfortunately, Elements offers
no quick mask function.*

Before

This charming image of a rose has a lovely sense of shallow depth of field, however,
the individual rose petals have become slightly soft in the final image. I wanted to
make a selection of just the flowering rose head in order to sharpen it and one
extremely reliable way of doing this is with the quick mask option.

1 Editing in quick mask mode

To move into the quick mask mode all you need to do is press **Q** or to click on the **QUICK MASK** icon at the bottom of the Photoshop toolbox.

2 Red painting

Now using the **BRUSH** tool (**B**) and selecting a medium-sized soft-edged brush you can start to paint the mask onto the image; in this case I painted all around the rose head, leaving the opacity at 100%, which you can see in the toolbar at the top of the screen.

3 Creating the selection

Now in order to change the painted mask into a selection all you have to do is press **Q** to edit in standard mode (or click on the **STANDARD MODE** icon, next to the **QUICK MASK** icon). When you do this the red painted onto the image turns into an outlined selection of 'marching ants'.

4 Inverting the selection

The physical selection is actually the wrong way around at present, if sharpening was applied now the area outside of the rose head would be sharpened. To fix this problem simply choose **SELECT → INVERSE**; this will invert the selection made, making sure any future alterations apply only to the rose head.

5 Adding sharpness

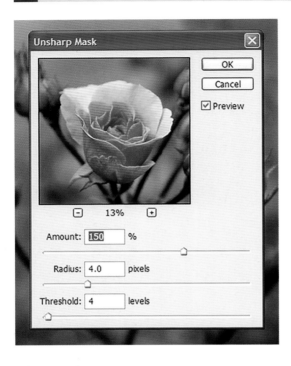

Now you can apply sharpening to the selection by choosing **FILTER → SHARPEN → UNSHARP MASK** (see Chapter 6 for help with sharpening). I chose to set a generous amount of sharpening using the commands in the **UNSHARP MASK** dialogue box, using an amount of 150% with a radius of 4.0 pixels and a threshold of 4. Once done, click **OK**.

Hints and tips

To get more control over the size of the selection made by the mask you may want to consider adding a feather to the selection area. Using a feather amount will soften the way the edge of the selection blends into your image, depending on what alterations you make to the selected area. Choose **SELECT → FEATHER**, and then type in a radius amount, using an amount between 5–10 will soften the transition nicely between the selected area and the outlying area of your image.

If you find you have made a mistake when painting on the mask you can easily subtract from the selection by switching the foreground colour to white and painting over the red. Simply press **X** to toggle the foreground colour between black and white.

The last thing to do is to just remove the selection that was created earlier as the marching ants will stay on the screen until they are commanded to go. To do this simply choose **SELECT → DESELECT**.

See also:

◄ Altering highlights, *page 96*

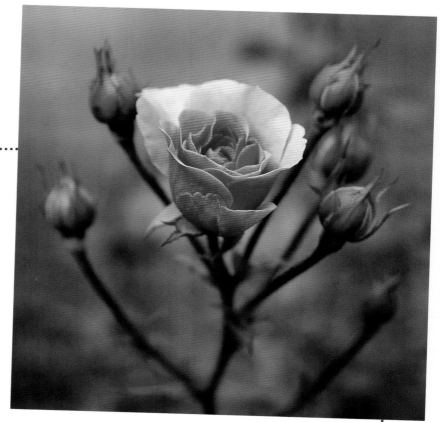

After
Here is the final result with just the rose head and petals sharpened. This demonstrates how you can use the quick mask mode to make a very fast selection of one area of the image, which you can then go on to manipulate later.

Sharpening Made Easy

Basic sharpening

One of the last functions to commonly be performed in image manipulation is that of **sharpening**. Once you're happy with the other alterations that you have made all you need to do is get the sharpening right.

Most digital cameras can be set to a certain level of sharpness and it's generally best to set at normal or even low sharpness as it's always better to have the option to be able to sharpen later on computer. This tutorial introduces the most commonly used sharpening tool and the easiest one to get to grips with: the unsharp mask filter.

Before
This image, taken at the modern Oriente train station in Lisbon, is far from sharp, there are various elements and features which need stronger definition.

1 Selecting unsharp mask

The first step is to open the unsharp mask filter, simply select **FILTER → SHARPEN → UNSHARP MASK.**

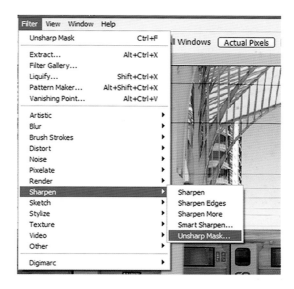

2 Putting back the sharpness

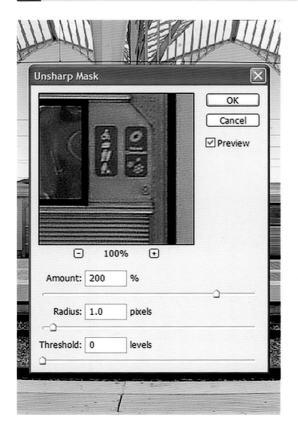

The unsharp mask dialogue box is certainly one you will be seeing a lot of when working with your digital images. There is a large preview screen that can be adjusted in magnification with the – and + symbols below it; effectively you can zoom in on an important part of the image and be able to see how the sharpening is affecting that area. Below this you have the **AMOUNT**, the most important part. This is the amount of sharpening applied to the image. In this case I used an amount of 200% which is a lot, but perfect for this particular scene. Then there is the **RADIUS** which controls how many pixels from the edge the amount of sharpening is going to effect; for example where one subject sits in front of another you want to sharpen the outer edge to bring back definition, in this case I chose a fairly low amount of 1.0 pixels to be effected. The **THRESHOLD** determines how different each pixel must be before it's counted as an edge pixel to be sharpened by the filter. The lower the threshold value the sharper the image will be, in the case of this image I left the threshold at **0.**

Basic sharpening

See also:

▶ High-pass sharpening,
page 118

▶ Lab sharpening,
page 122

Jargon Buster:

Unsharp mask

You may well wonder where exactly the term unsharp mask comes from. Well, unsharp masking was originally a photographic trick performed in the darkroom which involved exposing photographic paper to an underexposed and blurred positive film copy of the negative which was sandwiched with the original negative. Exposing in this way would create similar results to the unsharp mask filter used in Photoshop.

After

The final result for this general sharpening is impressive: edge detail is brought back into definition and lines and contours are far better defined within the image. This type of general sharpening can work well for a scene like this, but keep reading to find some other examples of different sharpening settings.

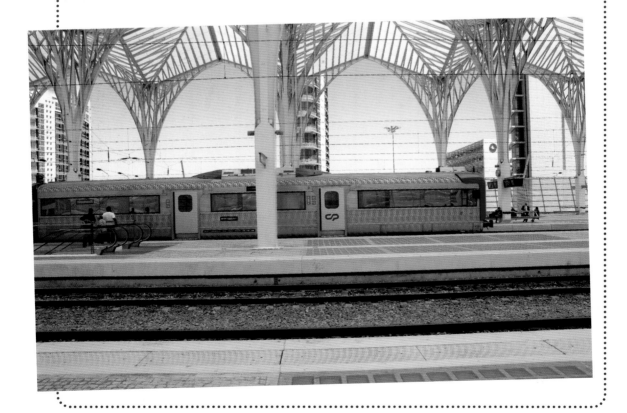

You can come up with a whole different range of sharpening styles using unsharp mask and here are the outlines of a few settings that you might want to try using yourself.

ULTRA SHARPENING To get high-end sharpening for either a picture that needs rescuing from being too soft or one that has defined edges, such as architecture, you can try these settings: use an amount of 70% which is then balanced with a hard-edged radius of 4.0 pixels, this is then slightly counteracted by a threshold of 3.

PORTRAIT SHARPENING For general sharpening of portrait subjects, particularly for head-and-shoulder shots, try using these settings: amount 75%, radius 2.0 pixels and threshold 3 levels.

GENERAL USE SHARPENING A general use sharpening that you may want to try on any image is this one: use an amount of 90% and then a radius of 1.0 pixels and a threshold of 4 levels. This is a good sharpening setting that can be applied to a wide range of images to produce average sharpness with good results.

High-pass sharpening

A more advanced form of sharpening than the basic unsharp mask technique that you may want to try is that of **high-pass sharpening**.

This involves using the high-pass filter to allow Photoshop to selectively sharpen certain parts of the image to achieve a high-end result. This tutorial shows how you can quickly and simply apply this technique to your images.

Before
My starting image was a chance shot taken on the River Bayonne in France, which turned out a little soft as the focus is a fraction out.

1 Duplicating the layer

The first thing to do is to duplicate the layer; the idea is to apply any changes to this layer before making a final decision to commit to the final image. Start by selecting **LAYER → DUPLICATE LAYER** to create a separate layer to work on.

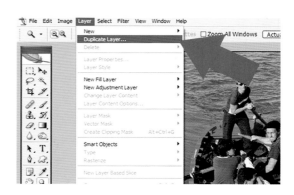

2 Naming the layer

When selecting the duplicate layer a dialogue box appears, as below, I chose to name the background layer 'high pass' and clicked **OK**.

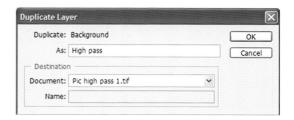

3 The high-pass layer

Now when you open the layers palette (**F7**) you can see the background layer and the duplicate layer for the high-pass sharpening.

See also:

◄ Basic sharpening, *page 114*

► Lab sharpening, *page 122*

4 Putting on the overlay

The next thing you have to do is to change the **BLENDING** option used by Photoshop from **NORMAL** to **OVERLAY**; this is a critical part in making high-pass sharpening work. Once this mode is selected you can see that the colour of the image changes greatly, this is nothing to worry about as it will be rectified in the next step.

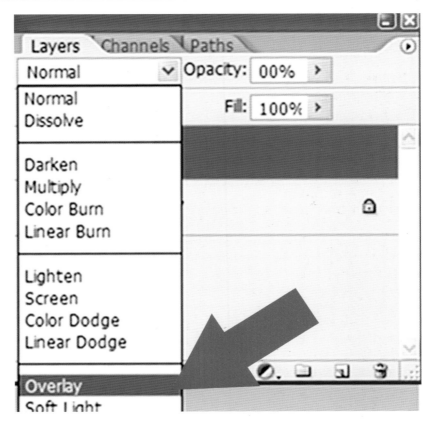

High-pass sharpening

High-pass sharpening

5 Going through the pass

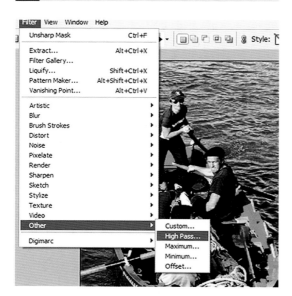

Now it's time to engage the high-pass filter. To do this simply click on **FILTER → OTHER → HIGH-PASS** to bring this function to life.

Hints and tips

Note that you don't have to use **OVERLAY** as the blending mode to achieve high-pass sharpening. Try experimenting with other modes such as **HARD LIGHT** or **SOFT LIGHT** as two alternatives to make sure you get the right sharpening result.

6 Pitching the radius

Once the high-pass filter is open you are presented with a dialogue box that allows you to control how much effect the filter will have in the image.
The slider at the bottom controls the radius of how many pixels are affected by the filter, the higher the radius the more the image is sharpened. I want to keep the effect fairly natural so in this using a radius of 2.5 was just right. But you will want to experiment with the radius to get the right result.

7 Putting back the colour

It's worth noting that using the high-pass filter can often lead to a loss in colour saturation. To resolve this simply use the hue and saturation tool to bring the colour saturation up a notch. Select **IMAGE →** **ADJUSTMENTS → HUE/SATURATION** or **ENHANCE → ADJUST COLOUR → ADJUST HUE/SATURATION** and adjust only the **SATURATION** slider. I moved it to +15 to bring back a good level of colour saturation in the image. Once done click **OK** and at this point flatten the two layers to make one, **LAYER → FLATTEN IMAGE**.

After

Here is the final image. The high-pass sharpening technique creates a unique effect in allowing selective sharpening to occur within the image. The high-pass filter is excellent at cleaning up edges and accentuating transitions, where the boat meets the water, for example, whilst leaving the smoother transitions, such as facial features, untouched.

High-pass sharpening

Lab sharpening

For all landscape and portrait photographers, if there is only one sharpening technique that is worth memorizing then it has got to be the **lab sharpening** mode.

Lab sharpening reduces the effects of jagged edges and halos in those images which you want to apply a higher amount of sharpening. Lab sharpening works by applying the sharpening to the lightness channel which is where the luminance detail of the image is kept: it thereby

sharpens data away from the colour information, which is how the effect creates impressive results. In this tutorial the effect is shown on a portrait image, but it can be applied to nearly any image you wish to work with. Unfortunately, the lab colour mode is not available in Elements.

Before
This portrait image was taken in a studio, with a digital SLR set to a normal amount of sharpening. This has recreated the scene with a slightly soft edge. This is generally a common issue with digital SLRs; the images are soft to allow you to add the amount of sharpening that you want to add in post manipulation.

1 Changing to lab colour

The first thing to do is to change the image from the RGB colour mode to work in the lab colour mode. This is simply done by selecting **IMAGE →** **MODE → LAB COLOR**.

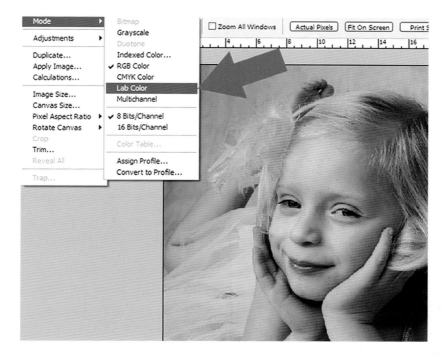

2 Looking to the lightness

Now if you press **F7** and click on channels, or select **WINDOW →** **CHANNELS**, you can see that you have four different channels that make up the image (this is a different set of channels to that which normally makes up the RGB image). You are concerned with the lightness channel as it's this part of the image, the luminance, that you want to sharpen. Make sure you click on the lightness channel to engage it.

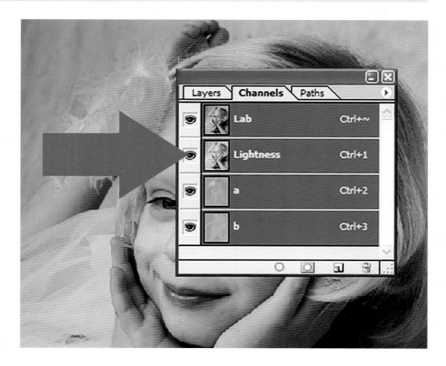

3 Turning black & white

When selecting the lightness channel one of the first things that will happen is the whole image will turn into black & white: when you apply the sharpening you have to use a keen eye to make sure you can see just how the image is changing.

4 Putting on unsharp mask

Now it's time to lay on the sharpening, choose **FILTER → SHARPEN → UNSHARP MASK**. I sharpened the image to 150%, fairly strong, but leaving the radius not too great at 1.2 pixels, with the threshold left at 0 levels. Once done, click **OK**.

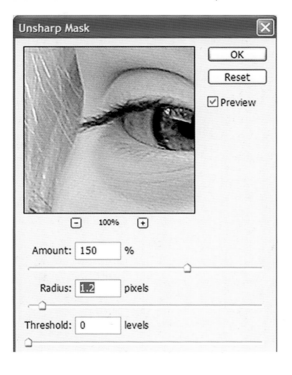

See also:

◄ Basic sharpening, *page 114*

◄ High-pass sharpening, *page 122*

Hints and tips

Save yourself time by making lab sharpening an action. An action is where you can perform a set of functions in Photoshop, record what you did, then simply play back at a later date. For the making of this book I did just that and my lab sharpening action is one of the most common actions that I use. To create an action simply click **WINDOW → ACTIONS** then select the new action icon and click **RECORD ACTION**. Name the action and start recording. Press the square icon to stop. Then when you want to repeat the action simply press the play triangle at the bottom of the window.

It's worth checking the image in colour to see just how the sharpening has affected it. Simply go back to the channels palette by pressing **F7** and then click on **LAB**, this engages all the channels and allows you to see the image in colour.

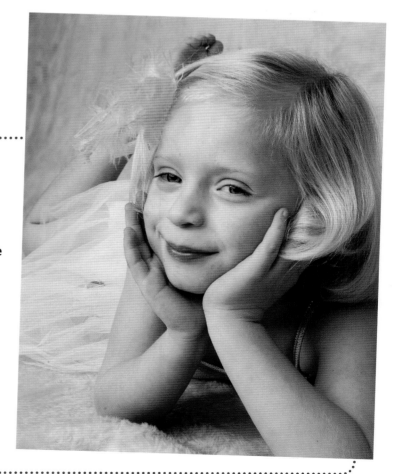

After

As I was happy with the result all I needed to do was to convert the image back into RGB simply by selecting **IMAGE → MODE → RGB COLOR.** Now the image has had the lab-sharpening treatment, giving a great result and helping to avoid issues such as colour noise and reducing the chance of sharpening halos appearing within the image.

[7]

Monochrome Made Easy

Monochrome images

In this section we will be looking at creating black & white images.

With Photoshop there are a number of different avenues to take in order

to create a **monochrome** result.

Some methods are better than others in terms of control and quality output and the next few tutorials will review these techniques. To get

started, however, here are a few of the very simplest ways that you can achieve a black & white image in just a few seconds.

1 Going grey

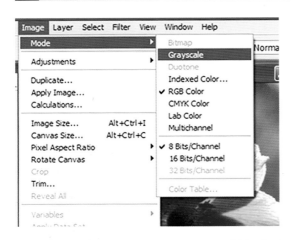

The simplest way to create a black & white shot from a colour image is to change the colour mode from the standard RGB file into greyscale. To do this simply select **IMAGE → MODE → GRAYSCALE**.

2 Discarding the colour

After selecting greyscale a dialogue box appears asking if you want to discard colour information, for this is exactly what Photoshop will do; it simply removes the colour information from the image to leave you with a black & white image. If you check the colour channels you'll see the RGB channels are replaced with just one channel, the grey channel. This method creates a black & white image quickly, but doesn't leave you with much control over the final result.

3 Monochrome through hue and saturation

Another method of creating a black & white image is using the hue and saturation tool. To engage this function simply start by selecting **IMAGE →ADJUSTMENTS →HUE/SATURATION** or **ENHANCE → ADJUST COLOR → ADJUST HUE/SATURATION.**

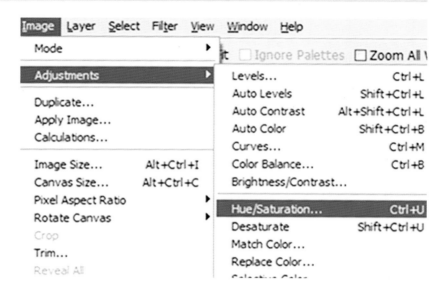

4 Taking out the colour

In the hue and saturation function there is the option to desaturate the colour information in the image, in this case set the **SATURATION** slider all the way over to the left to give **–100** and all the colour information is gone leaving you with a black & white image.

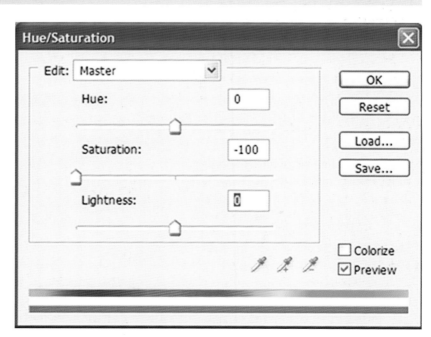

MONOCHROME MADE EASY

5 Desaturated method

Another route to make a black & white image is to simply desaturate the image directly through the image menu, select **IMAGE → DESATURATE**. This will take away the colour; although you still have the RGB channels the colour saturation is literally stripped away You can only do this using the previous method in Elements.

Jargon Buster:

Greyscale

What exactly is greyscale? Well, greyscale is in fact a system for making black & white images using a number of steps or gradations. For example a greyscale image using just two steps would be a high contrast image comprising of pure black & white. For most conventional images, however, the greyscale image is converted into 256 steps, as used in Photoshop, which allow for a smooth transition of tones. So, when an image is converted from RGB (red, green and blue channels) to greyscale the original colour channels (and colour data) are lost and the image represents all those colour tones with 256 monochrome tones.

6 Changing the channels

A more interesting method is to use the channel mixer; start by selecting **IMAGE → ADJUSTMENTS → CHANNEL MIXER**. However, again this is only available in the full version of Photoshop.

7 One click for monochrome

When the channel mixer dialogue box appears you will see a **MONOCHROME** check box in the bottom left-hand corner; click on this and the image is turned into black & white. Click **OK** to leave the channel mixer and return to work on the image. This option does allow for more control and it is this element of control that we will look at later, on page 142.

Hints and tips

When working with the hue and saturation function and using the saturation slider to turn the image into black & white you may well want to think about leaving a bit of colour in the image. The result is still very monochromatic but leaving some colour can give a depth of added interest by retaining some of the image's original colour.

If you turn your images into black & white using the channel mixer then the RGB channels are still open. One trick you might like to try is to use the Photofilter to tone your image. Select **IMAGE → ADJUSTMENTS → PHOTOFILTER** and try using either the warm-up or cool-down filters to create brown and blue toning accordingly.

See also:

▶ Conversion calculations, *page 132*

▶ Using the lightness channel, *page 139*

▶ Using the channel mixer, *page 142*

▶ Creating duotones, *page 144*

▶ Creating an infrared effect, *page 148*

Conversion calculations

This tutorial introduces the **conversion calculations** method to create a black & white picture, a more advanced method but one that you can easily get to grips with after some experimentation.

One thing that most Photoshop users find fascinating when manipulating images is the ability to turn their pictures from colour to black & white. In fact Photoshop offers a plethora of methods for creating black & white images, some of which achieve better results than others.

What becomes of particular interest to photographers is the ability to create images through the digital medium that simply could not have previously created in the traditional wet-process darkroom. The first thing to point out is that although many cameras incorporate a black & white function it's preferable to shoot images in colour and then use Photoshop to convert to black & white. This way you have far more choice and overall creative control. Unfortunately, this is only suitable for the full version of Photoshop.

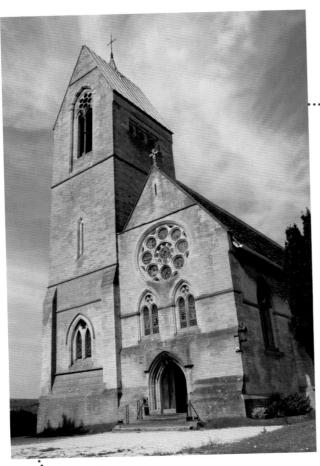

Before

Starting with a colour image and using the power of calculations enables you to combine different elements of the image's colour channels to create a more dramatic final black & white image. In my opinion this is one of the most creative ways to make black & white images. My chosen image, a picture of Selsley church in Gloucestershire, England, starts off in colour. Even in colour it has a dramatic feel and we can begin to imagine it in monochrome. I used the calculations method to make the image black & white but before I did so I wanted to take a look at the RGB channels for reference.

1 Channel hopping

Start by pressing **F7** which will bring up the layers box, then click on the **CHANNELS** tab and now you can see four different thumbnail images. It's the red, green and blue channels that you're interested in as they each represent a different type of black & white image that could be achieved when converting to black & white through that individual channel.

2 Over on the red channel

Now to get an idea of what each channel has to offer you can click on the red channel and the image will turn into black & white. The red channel portrays all the characteristics of combining a red filter with traditional black & white film in an analogue camera, giving a darkened sky with plenty of drama. Also take a look at the other channels, green and blue, in this case the green channel also gives a favourable effect, from which I conclude that a combination of elements from the red and green channels would be the best route to creating my final image.

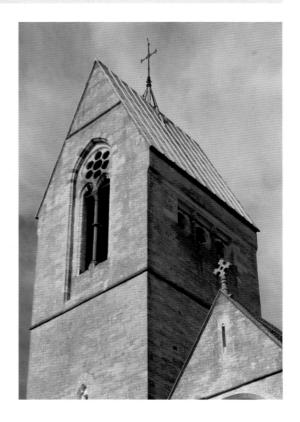

MONOCHROME MADE EASY

3 Calculation time

The next step is to click back on the RGB channel and to then open up the calculations dialogue box, **IMAGE → CALCULATIONS**. The calculations function will allow you to take two different or similar colour channels and blend them together to create just one black & white image. It will also allow a variety of blending options to be used, as would be found in layers.

4 Blending the channels

I knew from my previous investigation work that the red and green channels would give a promising result so the best thing to do was to try blending these two channels together. In this case I made source 1 use green as the channel and source 2 use red. I've experimented with different blending options and found that overlay produces the best result.

5 Back to black & white

Now looking at the preview image, as created by calculations, you can see the sky has turned deep and moody and the image packs plenty of contrast. The result is most reminiscent of using a red filter with black & white film. However, in this case I thought that the highlights were turning out too bright and this is why I went back to alter the settings in the calculations dialogue box to get the perfect result.

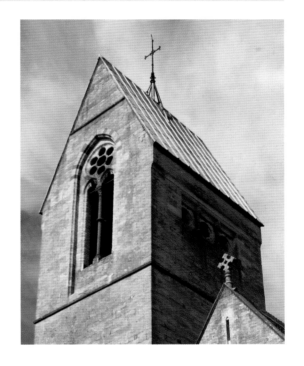

6 Tweaking the opacity

In order to get the contrast spot on I altered the opacity setting and pulled it down to just 75%, this adds some detail into the highlights rounding off the image perfectly. When you have the black & white image just as you want it, the last thing to do is to change the result drop-down box to **NEW DOCUMENT** so that you can actually create a new digital file of your black & white image. Once done, click **OK** and you have the final image.

Conversion calculations

7 Black & white blend

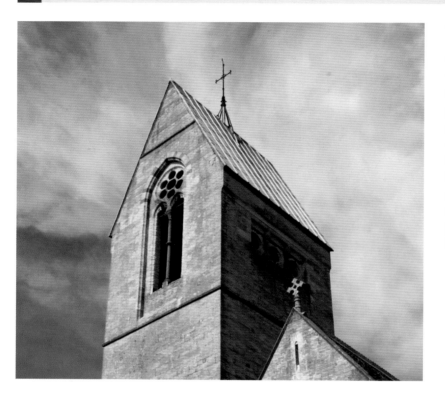

Once your image is looking up to scratch you need to convert it from multi-channel mode to pure greyscale, to do this simply choose **IMAGE → MODE → GRAYSCALE**. The last thing I wanted to do to the image was to apply some burning in, just like you would do in the darkroom.

See also:

▶ Using the lightness channel, *page 139*

▶ Using the channel mixer, *page 142*

8 The perfect burn

In order to make a perfect burn I chose to work using layers rather than using the traditional burn tool, to make sure the black & white image doesn't get left with any bruised pixels. Start by selecting **LAYER → NEW → LAYER**, a dialogue box will appear, as below, and change the mode to **OVERLAY**; then click the check box on **FILL WITH OVERLAY-NEUTRAL COLOR (50% GRAY)**. Once this is done, click **OK**.

9 Pushing the detail

The next step is to select the paintbrush tool **(B)** and, using a medium-sized round-edged brush set to an opacity of 30%, I started to paint detail back into the highlight areas of the church. As you do this you can see in the layers palette, on layer 1, the areas that you are burning in to add in the detail.

Hints and tips

Don't forget to experiment with the different blending options in calculations; using **MULTIPLY** for example will darken and intensify the image for a more dramatic result.

One alternative to creating a black & white image is to work using the hue and saturation function. Within the dialogue box you can alter the colour saturation, and as you pull the saturation slider to the left into minus figures the image turns to monochrome. You can, however, leave a hint of colour in the image which can make for an interesting and attractive effect.

Another method for creating a black & white image is to create a greyscale image using the lab colour method. Simply select **IMAGE → MODE → LAB COLOR**, the image converts into lab colour, looking no different, but under the **CHANNELS** tab in the layers palette (**F7**) you will see that there is a new and different set of channels to that of the regular RGB channels. In this case you are interested in the lightness channel, you click on this and then the image converts to black & white. The next step is to go back to **IMAGE → MODE → GRAYSCALE** to remove the other channels in leaving you with a pure greyscale image.

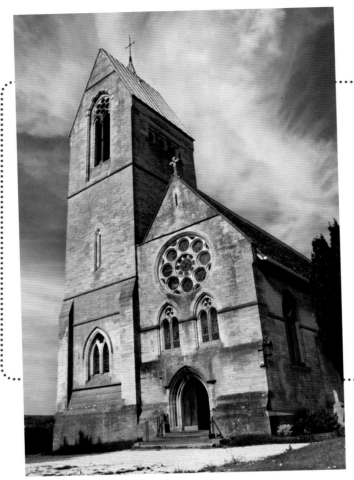

After

Having selectively burnt in the brickwork of the church just to fine-tune the contrast of the image, the image is very different from its colour original and is a testament to the power of Photoshop, showcasing how you can create new and rewarding black & white images with controlled results.

Jargon Buster:

Noise

Noise can be used in a similar way to film grain to add an artistic effect to your image. Obviously you will lose detail, but it can be attractive and create some striking results. Simply select FILTER → ADD NOISE and juggle with the settings until you are happy with your effect.

Using the lightness channel

The next method for creating a black & white file is by using the **lightness channel** in lab mode. This is a slightly simpler technique than the calculations method but still offers good control over the result.

Using the lightness channel to convert from a full-colour image to black & white allows you to adjust the luminosity in the image, without having to get too involved in the colour settings. A simple approach, but one that still offers a lot of control. Again, however, this tutorial is not suitable for Elements, which does not give access to the lab mode.

1 Selecting lab color

The first thing to do is to get Photoshop to change from RGB mode into lab colour mode. To do this simply click on **IMAGE → MODE → LAB COLOR**.

Before

My starting image was a portrait which I wanted to turn into black & white. Turning portraits to greyscale is a popular endeavour these days and using the lightness channels offers us a nice balanced way of getting a good result and can be easier to use than the previous calculations method.

2 Tuning to the lightness channel

Now that you have converted the image to lab color mode you need to take a look inside the channels palette (**F7** and click on the **CHANNELS** tab). You will see there are four channels, in RGB mode these comprise of a master RGB channel and separate red, green and blue channels. But in lab mode there are a different set of channels, the luminosity, which is effectively the lightness channel, is separated away from the colour data which is split into two separate channels: a and b.

3 Black & white beauty

In this case you only want to work with the lightness channel. Click on the lightness channel and instantly the image becomes greyscale on screen. At this point discard all the other channels and just work in the lightness channel. In order to do this select **IMAGE → MODE → GRAYSCALE**; you are prompted to check if you want to discard other channels, choose **OK** to remove the other channels.

Now you have a pure black & white image from the colour original. However, you want to have a bit more control over the overall exposure process of the black & white image you have created and in order to do this you make use of layers to tweak the image to get the best out of it.

4 Layer control

To get better control of the tonality of the image start by creating a new duplicate layer of the image, simply press **CTRL-J** (**CMD-J** on Macs) to create a new layer and then change the **BLENDING** mode in the top left from **NORMAL** to **MULTIPLY** by clicking on the drop-down arrow. At this point the image becomes much darker than the original.

The next step to correct the tonality is to use the **OPACITY** slider to lighten up the image, in this case I used the slider to take the opacity down to a level of just 50%, which brings back the shadow detail.

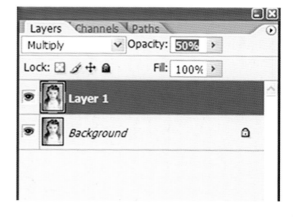

 In this tutorial we used **MULTIPLY** to control the tonality but you can also try using the blending mode option of **OVERLAY** to get a really punchy result. Simply work the same way, just select overlay and then change the opacity to suit your preferences.

 If you have a batch of images you want to work with, it may well be worth setting up an action. Simply click **WINDOW → ACTIONS** then select the **ARROW** and click **RECORD ACTION**. Name the action and start recording. Click the square icon to stop. Then when you want to repeat the action simply press the play triangle at the bottom of the window.

See also:

◀ Calculated conversions, *page 132*

▶ Using the channel mixer, *page 142*

After

And here is the final image using a combination of the lightness channel and layers to get the desired result. This offers you a simpler method than calculation but also gives you an element of control over the final tonality of the image.

Using the channel mixer

When creating a dynamic black & white image from a colour picture it is key to use Photoshop's functions to maintain control over the process and final result. One method which allows greater control is the **channel mixer**.

In fact using the channel mixer to create black & white images allows you to easily replicate some of the effects that are achieved in black & white photography using coloured filters. Again, like

the other more advanced monochrome conversion options, this tutorial is only suitable for the full version of Photoshop as it relies on the channel mixer dialogue box.

Before
This image, taken on Weston-Super-Mare pier, England, combines dramatic clouds with a low sun in the sky. The high-contrast dynamic makes it perfect for working with in black & white.

1 Channel hopper

See also:

◀ Calculated conversions, *page 132*

◀ Using the lightness channel, *page 139*

To find the channel mixer function simply choose **IMAGE →** **ADJUSTMENTS →** **CHANNEL MIXER**.

2 Going monochromatic

When you open the channel mixer the first thing you need to do is to convert the image into black & white; this is done by clicking on the monochrome check box in the bottom left-hand corner. When this is done you can see there are three source channels that make up the black & white image – red, green and blue.

Hints and tips

If you need to alter the overall brightness of the image just make use of the **CONTRAST** slider in at the bottom of the channel mixer box.

If you want to be able to go back at any point and change the alterations you made in the channel mixer then it can be worth making an adjustment layer. Simply choose the **CHANNEL MIXER** adjustment layer from the bottom of the layers palette when you click on **CREATE NEW OR FILL ADJUSTMENT LAYER**.

3 Mixing up the colours

Now here is the golden rule: all of the values that you see in the channel mixer should, one way or another, add up to 100% across the three colours. I really wanted to go for a dramatic effect, so I lowered the red channel down to +70% which I then counterbalanced with the green and blue channels by setting +20% and +10% respectively.

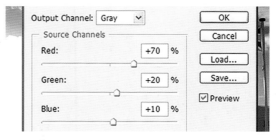

After
Here is the final image. Using this method allows for more experimentation and also control over the final image, allowing you to create very visually expressive results that replicate a range of traditional filters.

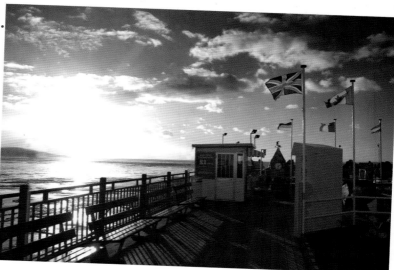

Creating duotones

Duotones are a unique process, somewhat similar to split-graded toning as used in traditional black & white printing, and this tutorial will show you how to create them.

With a duotone in Photoshop you are able to mix different colours in a monochrome image, in essence duotone means you are working with two tones or two colours. Photoshop allows you to specify a range of colours to mix together and uses a curve to blend them. This technique is not the easiest to get to grips with at first, but with a little patience and some trial and error you can soon work some digital magic. Unfortunately, the duotone mode is not an option in Elements.

See also:

▶ Creating an infrared effect, *page 148*

Before
I start with a colour image of a gerbera; the first thing to do is to change the image to greyscale.

1 Going greyscale

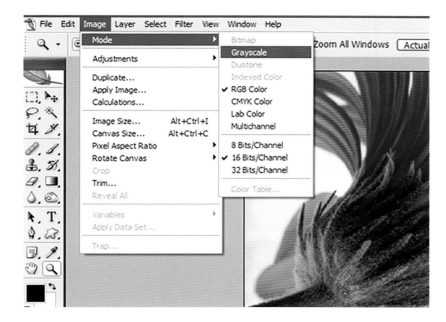

To get the image into greyscale simply choose **IMAGE →
MODE → GRAYSCALE**.
A dialogue box appears asking if you want to discard the colour information, click **OK** and the image will turn into black & white. Once this is done you can move onto the next step of working with duotones.

2 Selecting the duotone

Now the image is in black & white the next step is to enter the duotones mode, to do this simply click on **IMAGE → MODE → DUOTONE**.

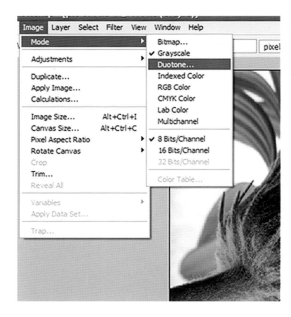

3 Just your type

The next thing that happens is the **DUOTONE OPTIONS** dialogue box will appear, the irony here is that although you selected duotones Photoshop defaults to monotone so you need to select duotone from the **TYPE** drop-down box. Click on the drop-down arrow and highlight the duotone function.

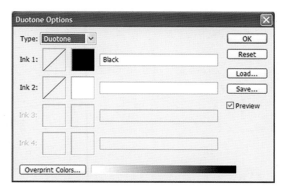

4 A tale of two inks

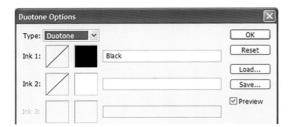

Now you can get down to the nitty gritty of creating your duotone. Taking a look at the duotones options you can see that you have an ink 1 and an ink 2. This is where you can specify the two colours, or tones, which you want to blend together in one image. The box with the straight line running diagonally through it is a curves function, it allows you to control how each colour is distributed throughout the image. The first ink is set by default as black, and in this case I wanted to blend black with one other colour to get a more natural effect.

5 Colours on parade

Double clicking on the blank white box for ink 2 will bring up a selection of colour libraries for you to choose your second colour for the duotone. In this case you can choose from the pantone colour library. Scrolling down the different colours I chose a light blue one and clicked **OK**.

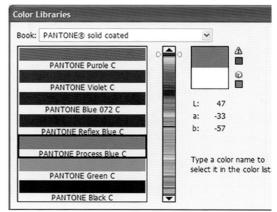

Hints and tips

🖱 At the beginning of this tutorial you selected duotone but you can be more adventurous and select the tritone mode and mix up three colours to get more varied results. Simply select **TRITONE** from the drop-down box in the **DUOTONES OPTIONS** dialogue box, as seen below.

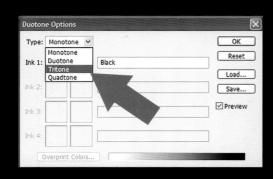

🖱 If you go to save the image as a duotone you will find the amount of file formats that you can save in becomes limited. For example if you want to save the image as a jpeg then you need to turn the image back into RGB mode first, simply select **IMAGE → MODE → RGB COLOR**.

🖱 Don't forget you can save your duotone selection, to apply to other images, click on **SAVE** in the duotones options dialogue box and save your selected creation to a folder. Simply choose to **LOAD** the selection when needed at a later date.

6 The duotone curve

The last thing to do is to work with the curve of the colour that you are combining with the black. Back in the duotones options box you need to double click on the **CURVES** box (to the right of ink 2) in order to bring up the duotone curve. This is where you can really have some fun as you can manipulate just how the second colour mixes in with the black. To the right of the curve you have a selection of values from 0–100. 100 represents the amount of colour that will be inserted into the shadow areas while 0 represents the amount of colour in the highlight areas. By typing a value in the blank white boxes. You can tell Photoshop to reduce the amount of colour in the given area of that point of tonality. So, for example, in this case to bring back more detail into the shadow areas I reduced the blue in

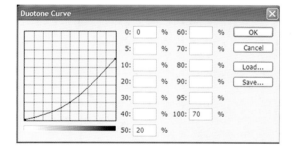

the 100 column by placing a value of 70%. After I did this I could see the shape of my curve change. To tweak the mid-tone values I entered a value of 20%, to reduce the blue applied to the mid-tones. This is enough to get just the right result, so I clicked **OK** to get my final image.

After
And here is the final image, balanced to perfection, similar to creating a blue-toned print in the black & white darkroom. It's worth spending plenty of time experimenting with this, particularly the values of the curve, to get that unique result that you are looking for.

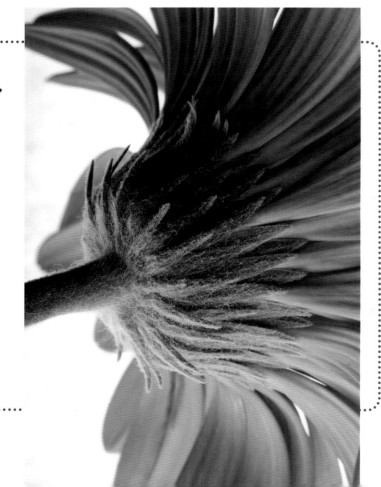

Creating an infrared effect

You may well have seen infrared images or even experimented with infrared film, but did you know you can create an extremely striking **infrared effect** for your images in Photoshop?

Using a colour image you can create your own infrared results using some more advanced techniques that will only work in the full version of Photoshop. Infrared produces a stark, eerie ghost-like effect which can add a real dynamic to your images.

Before
Here is my starting image; the plan is to take us from this colour image into black & white and then onto using special effects manipulation to achieve a final ghostly infrared effect.

1 To the channel mixer

The first thing to do is to select the channel mixer which will be our medium for turning this image into black & white. I select **IMAGE → ADJUSTMENTS → CHANNEL MIXER**. Once the channel mixer is open the first thing I want to do is click the little monochrome check box in the bottom left, this will instantly turn the image into black & white.

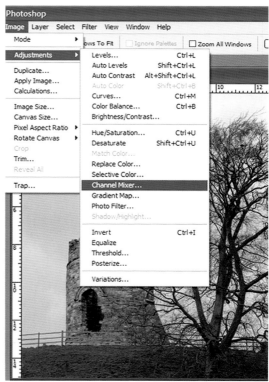

2 Changing values

Now with the image in black & white you will need to make alterations to each of the individual colour channels. It's a matter of working with extremes and I started with the green channel slider. I moved the green slider all the way to the right giving me a value of 200%. At this point the image became very bright, to counterbalance this I then moved the blue slider all the way to the left to give a value of –200%. The last thing to did was tweak the red channel, this was done by eye, in this case I set a figure of 115% to get just the right balance.

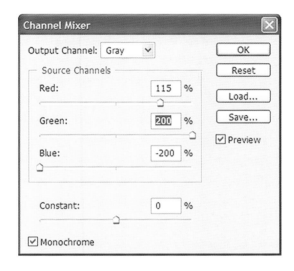

3 Pause for thought

At this point you can stop and take a look at the result: already the image has a more unusual look than that of standard black & white. But to get the effect just right you can employ a few more tricks to round the image off nicely.

4 Blurring up

The next step is to add some blur into the image, select **FILTER → BLUR → GAUSSIAN BLUR**.

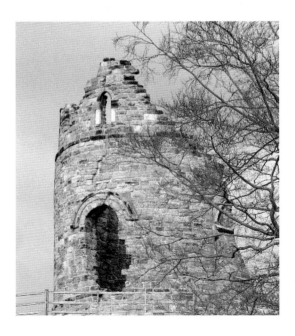

5 Choosing the radius

Once the gaussian blur dialogue box appears you can decide how much to apply. For this image I chose a radius value of 2.0 pixels to get a good all-round result. When done, just click **OK**.

6 Fading away on screen

The next thing to do is to soften the effect of the blur, but in a specific way; to do this use the fade function. Select **EDIT → FADE GAUSSIAN BLUR**, in the dialogue box you need to change the mode to **SCREEN** and then decrease the opacity to take the edge off the previous blur function. 15% gives about the right balance for this image.

7 Getting noisy

To get the real feeling of infrared you need to add some more grain into the image using the noise function. Select **FILTER → NOISE → ADD NOISE**.

8 Gritty grain

In the **ADD NOISE** dialogue box you want to tell Photoshop to add just the right level of grain to the image; in this case rising to a level of 15% is perfect, this even adds some extra detail into the highlights of the image.

Hints and tips

More of a reminder than a hint, don't forget it helps to work with images that contain lots of blue and green in order to get the best out of using this infrared technique.

See also:

◀ Creating duotones, *page* 144

After

And here is the final image. I have used various functions in Photoshop to recreate the ghostly effect of infrared, the addition of noise at the end helps to recreate the grained edginess characteristic of infrared black & white film.

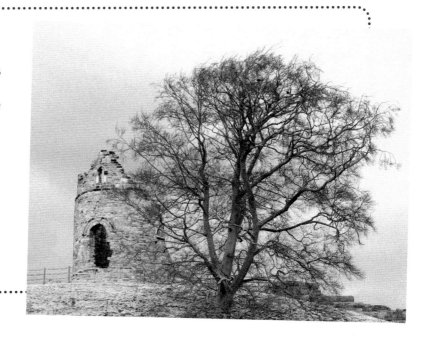

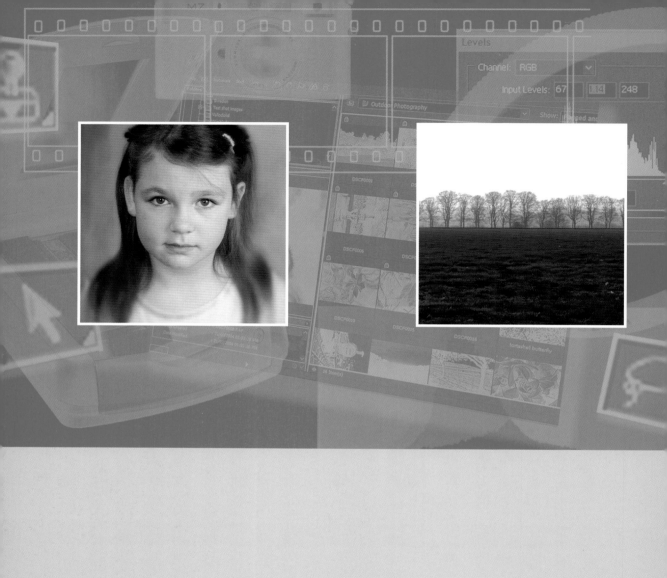

[8]

Special Techniques Made Easy

Stitching panoramas

If you like the idea of panoramic images, but don't feel like sticking images together on a cutting board or forking out for a really expensive panoramic camera then Photoshop makes it possible to create your own by using simple layers and **stitching panoramas**.

This tutorial shows you how to create a basic panorama by merging two seperate images together using layers. This process should also provide you with a starting point for *creating more complicated panoramas and other stitched images. Elements users can follow this tutorial, but will have to use the colour variations tool for corrections instead of curves.*

Before

The aim of this tutorial is to pair an image on the left with a second, continuation image to the right. But before you do this you need to create some extra canvas space to the right of this image, ready to layer the second segment into. So here is the starting point, the left-hand image.

1 Controlling the canvas

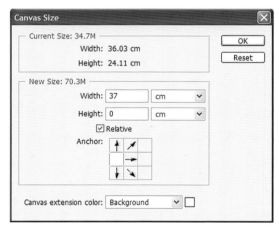

In order to create extra canvas go to **IMAGE →
CANVAS SIZE** or **IMAGE → RESIZE → CANVAS SIZE**
from here a dialogue box appears which will allow you to perform alterations to the canvas area. In this case I simply wanted to create extra canvas space to the right-hand side of the image. Make sure the **RELATIVE** box is checked and click the middle left-hand box in the **ANCHOR** grid; this will instruct Photoshop to position the extra canvas to the right-hand side of the image. Now key in how much extra canvas you want, in this case 37cm – a little more than the width of the image.

2 | Setting up the canvas

Clicking **OK** will close the canvas size dialogue box and Photoshop will automatically add the extra canvas space; a large white space will appear as seen below. You now have the space to import the next half of the image.

3 | Making a move

The next step is to open the second half of the panorama. Once it's open you can make use of the move tool (**V**) to drag and drop the image onto the white canvas, next to the left-hand segment. At this point you have just dropped the image onto the canvas; the next stage is to overlap and line up the two images.

See also:

◀ Using curves, *page 51*

4 | Match-making

In order to match the two halves up you have to make use of layers. As you imported in the right-hand side of the image Photoshop automatically created a new layer out of this segment. By going into the layers palette you can make a quick alteration to the opacity of the second image, in this case I lowered the opacity slider to 50%. As soon as I did this I could see through the top image to the one underneath, making it much easier to match up the two images.

5 Fine-tuning

The best way to fine-tune the image placement is with the move tool (**V**) combined with the cursor keys on the keyboard. It's also worth zooming in on the matching segments so you can see the alignment. Tiny movements can be made with the cursor keys, when the image is unaligned the edges will look fuzzy and blurred but as they align they will appear sharp, in this case I moved the image around until the blurred edges disappeared and my image was united.

6 Joined at the hip

Now you have matched up the two halves of your image you can raise the opacity back to 100%, the image isn't perfectly sharp but this will fall into place when flattening the layers later. I also decided to crop the image down removing any excess, blank canvas. However, there is one big problem; the two halves of the image don't match in colour tonality. This is often a problem experienced when making panoramic digital images as the exposure and colour temperature can change in each segment of the image. So the next step is to make use of the RGB channels in order to settle this discrepancy.

7 Tuning in the channel

Now if you go back to the layers palette (**F7**) you can click on the **CHANNELS** tab at the top, which will show you the colour channel breakdown of the image you are working on. Firstly you want to click on the red channel; once you do this your image will turn into black & white. In black & white it is clear to see the tonality difference between the two image segments.

 At this point Elements users should leave this tutorial, rejoining at the end of step ten to flatten the image. Instead of using the separate colour channels and the curves function you will have to choose **ENHANCE → ADJUST COLOR → COLOR VARIATIONS**; follow the prompts to adjust the colour and luminosity of each layer in turn.

8 Levelling off

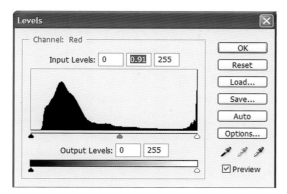

Go to **IMAGE → ADJUSTMENTS → LEVELS** to open up levels which will work solely within the red channel as previously selected. Now simply by moving the middle, mid-tone slider to the right the layer segment will become darker and begin to match the tonality of the left-hand segment of the image. Once the two sides match you can simply click **OK**.

9 On the other channel

Now the first channel has been altered it's time to do the same with the other two channels. Click on the green channel next and perform the same function of opening up levels and altering the tonality with the mid-tone slider to make both halves match. Once this is done repeat the same steps working through the blue channel. Once all channels are done click back onto the RGB channel to assess your changes.

10 Going curvy

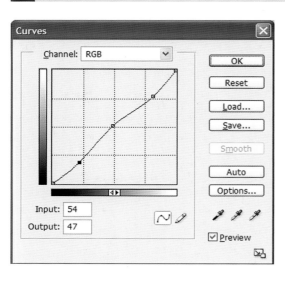

Returning to the RGB channel for this image, I could see that the colour differential has completely disappeared so the last thing to do was to make some final alterations to improve the image overall. **IMAGE → ADJUSTMENTS → CURVES** opens the curves function and allows you to pull the middle of the line up to lighten the mid-tone of the image, while dragging the line down on both the shadow and highlight areas to add detail into these areas. Click **OK** and simply flatten the open layer, **LAYER → FLATTEN IMAGE**. And with everything done you're ready to assess the final image.

After

Here is the final image: as you can see the tonality and colour matches perfectly all the way through the image. The seam is also faultless, providing you with a perfect panorama. This technique is one well worth trying with your digital camera or even with prints and slides scanned to files. Of course you can experiment with larger panoramas and once you feel comfortable with this technique try experimenting with three- or even four-stitch panorama images.

Hints and tips

Remember to take care when shooting your panoramic images. Shooting with a tripod can help greatly, and trying to avoid using ultra-wideangle lenses will minimize distortion that can make creating panoramas very difficult.

Also remember to make sure your images overlap for each segment that will make the panorama. An overlap of at least 20% is recommended when creating your images.

If you find there is any detectable seam in your panoramic image you can always gently use the clone or heal tool to erase away any sign of a join.

Creating vignettes

A vignette is a great tool to add that little extra something to an image. In this section we'll look at how to **create vignettes** to blur the image and focus the attention on a particular spot, in this case a portrait taken in a studio.

By combining layers with the Gaussian blur function it's possible to create a pleasing result which can work not just on portraits, but any suitable subject.

Before
Here is the starting image: although it is an attractive portrait it is spoilt by some distracting creases on the backdrop cloth. Using the vignette effect will not only eradicate this but it will also produce a very professional result that is flattering for portraits of this nature.

1 Double layers

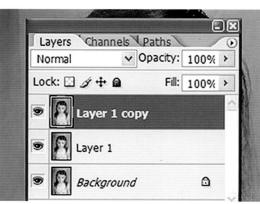

To start with you need to create two new layers, this is most simply done by pressing **CTRL-J** (**CMD-J** on Macs) twice, when you have done this you can see you have two layers in your layer palette (press **F7** to display on the screen). You need to click on the middle layer, labelled as **LAYER 1**, you also need to click off the **EYE** symbol next to layer 1 copy on the left.

2 Selecting the blur

Now you need to bring up the Gaussian blur function, this is done by selecting **FILTER → BLUR → GAUSSIAN BLUR**.

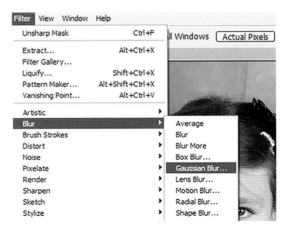

3 Blurred vision

When the gaussian blur dialogue box appears you should put some heavy blurring into play by choosing a radius of 9.5 pixels. Once done click **OK**.

4 Elliptical selection

Now you must define an area where the image will come into focus. You need to go back to the layers palette and click on **LAYER 1 COPY** (leaving the **EYE** symbol turned off). Then you can work with the elliptical marquee tool (**M**), to draw a selection within the image, focusing around the face. To select the eliptical marquee click and hold on the **MARQUEE** tool and select the **ELIPTICAL MARQUEE** from the list.

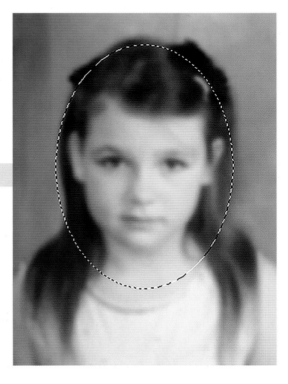

5 Feathers for selection

To make a smooth transition with the final blur effect it's important to set a feather on the selection. This is done by choosing **SELECT →
FEATHER**. I added a value of 60 pixels to get a good transition. Once done, click **OK**. The size of the ellipse will decrease slightly because of the feather.

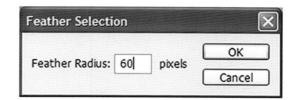

6 Making the mask

Now it's time to add in the mask: simply click on the **ADD LAYER MASK** icon to engage the mask. Click the eye symbol in 'layer 1 copy'. At this point the image can now have the layers flattened, **LAYER →
FLATTEN IMAGE**.

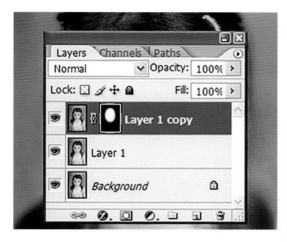

Hints and tips

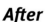 Use the feather radius to control the final transition of the vignette effect; don't be afraid to use a higher value if you want to make a smoother transition.

After
And here is the final result, a very flattering effect that draws attention to the eyes and facial features and hides any distracting marks in the background. You can also be creative with your blurring, using higher or lesser values of gaussian blur to create the right sort of effect to suit your image.

Merging images

Since the beginning of photography there has always been a tendency towards experimentation, from darkroom processes to cutting and pasting prints and **merging images**.

Today we can use digital manipulation to create seamless montage images. As this part of the book is all about advanced techniques and special effects this tutorial is going to show you how to combine two images to create one. In order to do this you will use the quick mask tool (so this is unsuitable for Elements), the gradient tool and the eraser. The first is an image of a magnificent sunflower, shot on a digital compact, the background rather spoils it so I deliberately shot an image of a blue sky which I could merge the sunflower onto to create a stunning result.

Before
Here is the first image in its raw form. To start off I made a selection of the sunflower so I could transfer it onto it's new background. Using the lasso tool can be very tricky in a case like this, so what I will do is draw a very rough lasso outline around the sunflower and then engage the quick mask option.

1 Creating the mask

Select the quick mask mode (**Q**) and draw around your subject with the brush (**B**). With the colour picker at the bottom of the toolbar set to default colours of black and white you can add more to the mask using the black paint.

2 Fine-tuning the mask

The next step is to zoom in close on the areas you want to work on. By doing this you can add to the mask with more control; using a small, hard-edged brush set at 100% opacity you can paint carefully and smoothly around the petals of the sunflower. The more accurate the work is the better the final selection will be.

3 Correcting mistakes

If at any point you accidentally add too much to your mask, go to the paintbrush colour and switch the foreground colour around to white. You can then simply erase the added mask away to correct your mistake.

4 The final selection

After painting into all the areas to add to the mask zoom out and check your work. The next step is to turn off the quick mask and go back to selection mode. **Q** toggles between standard mode and quick mask mode, which is located to the left of the quick mask tool. Once this is engaged you can see the 'marching ants' of your selection again. If the image doesn't match up correctly then you can jump back into quick mask and add to or subtract from more of the selection. At this point I'd recommend saving the selected area by going to **SELECT → SAVE SELECTION**, this way the mask selection is preserved as an alpha channel in the channels palette and can be loaded again if needed.

5 Blue sky days

The next step is to jump to your second image, in this case a nice stretch of beautiful sky, taken on a digital SLR. This will be the main background image that I will place the sunflower on. To start with create a new layer to do some manipulation on, **LAYER → NEW → LAYER**. I called this new layer **GRADIENT**. Now use the gradient tool (**G**) to create a graduated effect similar to a graduated filter, to make the sky more dramatic. Once you have selected the gradient tool you can go to the top left of the screen to work with the gradient toolbar. Use the linear gradient tool – by clicking on the drop-down arrow from the toolbar you can select what type of gradient you want to use; in this case I wanted to use **FOREGROUND TO TRANSPARENT**.

SPECIAL TECHNIQUES MADE EASY

6 Creating and blending in the gradient

With the gradient tool set up you now have a small cursor arrow with which you can draw a line to set up the gradient. The line you draw will denote where the gradient will start going from its darkest and gradually turning clear at the point where you end the selection with the line that you draw. In this case you can draw a gradient line from the top of the image down the middle to three quarters of the way down the image. Once drawn Photoshop will then automatically load the gradient. In this case I used a default black as my gradient, however, you can just as easily select and choose a different colour from the colour picker if you choose. With the gradient tool applied you can see from above the effect is rather unnatural to say the least. Next we will alter this to create a more flattering result.

As the gradient has been applied to a layer you can blend in the opacity to suit the final result. In this case I took the opacity down to 40% which in

effect creates a balanced darkening effect of the sky quickly and easily without having to use the burning tool. Note you can also make use of blending options in layers; experimenting with the soft light blending option, for example, can create a good result.

7 Merging the images

You can now move the selected area of the top image onto the backdrop. With both images open on your screen you can simply select the move tool (**V**) and pull the selected area of the sunflower and drop it into the middle of the frame. The first thing I noticed is that my selection was not quite as perfect as I had hoped with patchy areas showing around the petals where the mask wasn't quite right, so what I did next was tidy up any imperfections.

8 Cleaning up mistakes

To get your final work perfectly tuned use the eraser tool (**E**). By zooming in on the petals and using a hard-edged brush set at 50% opacity I gently erased any white edges, but also at this opacity you can gently blend in any hard-looking edges around the petals to create a more natural-looking match.

Hints and tips

🖱 When combining images it's important to keep both images at the same resolution, simply click **IMAGE → IMAGE SIZE** and the resolution is shown at the bottom, if necessary change the resolution so the two images match.

🖱 If you are moving a selection to an area with a similar background you may want to make use of a feather to blend in the final result, setting the feather to around 3.

🖱 Photoshop can allow you to create a drop shadow when you place a layered selection onto another image. This lets you recreate a realisitic shadow on a backdrop where commonly a shadow should be found. Simply go to **LAYER → LAYER STYLE → DROP SHADOW**. You can play with the options of the blend mode, opacity, distance, spread and size and use the preview options to create the perfect shadow to suit your image.

9 Adjusting the layers

Using the eraser tool all around the sunflower you can blend in the image to match perfectly against the backdrop. At this point you will have two active layers, one for the gradient and one for the sunflower, and you can work on these layers to fine-tune the result. First select the gradient layer and add some gaussian blur, **FILTER → BLUR → GAUSSIAN** – I used a radius of 10.5 to soften the sky for a more natural-looking depth of field. Using levels, I lightened the body of the flower to focus attention on it, while I darkened the skyline in levels giving a full-bodied contrast to the whole image.

After

And here is the final result, my sunflower is now bedded in a new home with a wonderful blue backdrop. Once you are happy with the final image flatten the image layers by going to **LAYER → FLATTEN IMAGE**. Combining images offers a handy tool to create more dynamic images, so give it a try.

Merging different exposures

Digital cameras are notoriously poor at holding highlight detail especially if our exposures are not spot on. The idea in this tutorial is to use Photoshop to **merge two exposures** into one in order to preserve the best of both highlight detail and shadow detail.

For some time now professional photographers have employed the technique of shooting not one but two images, one overexposed and one underexposed, and it is not just for professionals, in fact anyone with the full

version of Photoshop can try it. This tutorial shows you how, by combining two images, you can choose how to blend the images together in order to retain precise control in the final image, giving you perfect shadow and highlight detail.

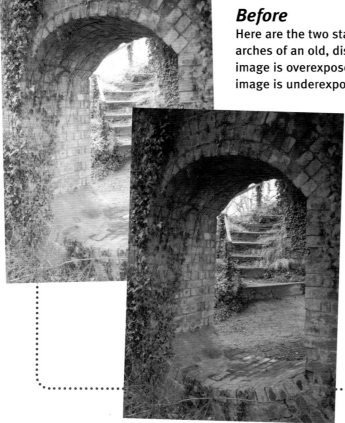

Before

Here are the two starting images, taken underneath the arches of an old, disused railway bridge. The left-hand image is overexposed by one stop while the right-hand image is underexposed by one stop. The aim is to combine the two images together and to preserve highlight detail from one while retaining the shadow detail from the other. In order to capture these two images a digital SLR was mounted on a tripod, which is essential to eliminate any movement that might occur between the shooting of the two images.

The auto-bracketing function was used to tell the camera to take two images, one above the recommended exposure and one below. Both images are opened in Photoshop, before clicking on the overexposed image to make it active.

1 The lighter layer

Open up the layers dialogue box by simply pressing **F7**. Then click on the background layer, which will become highlighted in blue. The next step is to place this background image on the underexposed picture. By engaging the move tool (**V**) and holding down the **SHIFT** key you can simply click and drag this **BACKGROUND LAYER** and drop it on top of the underexposed image.

2 The cover-up

Now in the underexposed image you can bring up the layers dialogue box again by pressing **F7**. You now have the original background layer and your overexposed image layer – as the opacity is set to 100% – completely covers the background image.

3 Masks on

The next step is to set up the layer so you can begin to reveal the detail of the background selectively. In order to bring back the detail underneath, make use of a layer mask. To do this select **LAYER → ADD LAYER MASK → REVEAL ALL**. Now if you look in the layers palette you can see that you have a blank layer mask. By etching away at this mask you can

reveal the original detail of the background layer underneath. In order to do this select the paintbrush tool (**B**) from the toolbox and set the foreground colour to black (**X** toggles the foreground colour between black and white).

Select a soft-edged brush from the paintbrush toolbar at the top of the screen and set the opacity at 40% which will give you an element of control over what you reveal. Work in light strokes and gradually build up the detail.

The next step is to pull back more detail around the image, but this time reduce the opacity to 30% and paint into the middle ground of the image revealing detail under the curve of the arch. If you now press **F7** you can check the layers palette again. If you look at the layer 1 mask you can see the areas that you have pulled back, so that you can keep a track of where you've been performing work in the image.

Merging different exposures

Hints and tips

While working with your layer mask if at any time you reveal too much of the image you can simply change the foreground colour from black to white (**X**) and paint back in any areas that you want to keep.

If you feel you don't really need to use the step-by-step method to reveal your image you can of course go for a straight blend of your images. Simply drag and drop your overexposed image onto the underexposed image and use the opacity slider to blend the two images together, you can judge by eye to get the best results.

When painting with the paintbrush tool its worth knowing that you can change the mode from normal to a whole host of other functions. Go to the paintbrush toolbar at the top of the screen, click on the **MODE** drop-down box and try experimenting with using hard light, vivid light or even pin light to get more intense results.

4 Rounding off

You can now see where you've pulled back detail – in this case under the arch – which starts to make the image more balanced. To finish off, perform one last layer fix by painting around the foreground of the image with an opacity of 20%, in this case around the main brick area of the arch.

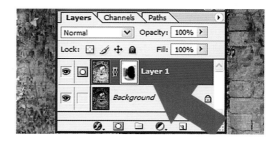

5 Adjusting the contrast

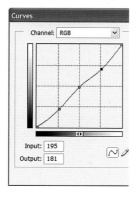

At this point while the layer mask is still active you can perform a quick trick to alter the contrast of your manipulation work. By opening curves, **IMAGE →
ADJUSTMENTS → CURVES,** you can create a curve adjustment that will just affect the areas you have revealed with the layer mask. In this case the alteration has to be very subtle, so I have just tweaked it carefully by pulling both the shadow and highlight detail down a little to gently improve the image contrast.

In terms of combining the two images you are now finished, so you can flatten the image, **LAYER → FLATTEN IMAGE.** However the colour balance in this image is far from good, the auto white balance of the camera has rendered the image very cold with strong greens and blues. In order to fix this go back to the curves function to colour correct the image.

6 Curves in colour

The first thing I wanted to do is to reduce the green tint by opening curves, **IMAGE → ADJUSTMENTS → CURVES** and choosing the green channel from the **CHANNEL** drop-down menu. I created three tag points, one in the middle for the mid-tone detail and one above and one below for the highlight and shadow areas. In all cases I pulled the curves line down a little and the green cast was eliminated. The next step is to choose the blue channel, and repeat the same steps, pulling down the three key points to remove any cast which will then dramatically warm the image up. Once done, click **OK** to return to the image.

7 Finding the level ground

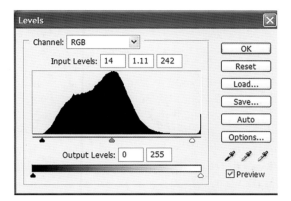

The final step is to use levels to finely adjust the contrast and unsharp mask for a touch of sharpening. To fine-tune the contrast open levels, **IMAGE → ADJUSTMENTS → LEVELS** to bring up the levels dialogue box. Simply pull in the left and right slider a touch while shifting the mid-tone slider to the left, adjusting by eye for the best result. Once done, click **OK**. At this point add some sharpening to the image, **FILTER → SHARPEN → UNSHARP MASK**; I used a radius of 1.3 with an amount of 130% to bring optimal clarity to this image.

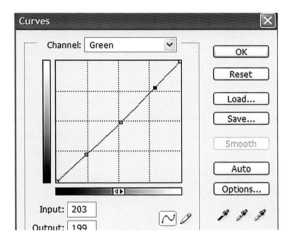

After

And here is the final image, a unique composite of two images to make one. This is just one example of how to use this technique and you can vary your method depending on the image. The technique can work particularly well when, for example, you want to produce an image where there is a strong highlight area that you want to preserve. So get your tripod out and give it a go.

Merging different exposures

Glossary

ADC / Analogue to digital converter The part of every digital device (camera or scanner for example) that can convert analogue continuous tone images into digital information.

Aliasing The appearance of jagged pixel edges that can be seen within any curves or lines of the image at or around 45 degrees. Anti-aliasing is the process used in Photoshop and other image software that helps to soften the edges of the image to reduce the effect of aliasing.

Algorithm A mathematical equation that gives a solution for a particular problem. In relation to photographic imaging this relates to a set code that will define how values of particular pixels will alter in an image.

Alpha channel This is a greyscale version of an image which could be used alongside the standard colour channels, for example, when making masks.

Artefacts Imperfections in an image which are generally caused by image manipulation, inherent flaws in the capture process and also by any computer errors which may manifest digitally themselves in the image.

Aspect ratio The ratio of the width of an image to its height.

Background image This is the base image which will be underneath any additional layers that have been applied to the image, it is the building block of your imaging work.

Batch processing The application of a series of commands that to multiple files at the same time. This is very useful for making changes to a folder of images which all need manipulating.

Bicubic interpolation A method of interpolation whereby new pixel data is created by calculations involving the value of the nearest eight pixels. This method is superior to other forms of interpolation such as bilinear interpolation and nearest neighbour.

Bilinear interpolation Similar to Bicubic interpolation, but only four of the nearest neighbouring pixels are used to reference how to create new pixels, thus the results are less potent, rendering softer results than bicubic interpolation.

Bit A unit of information that can only have one of either two values: 1 or 0.

Brightness range The range of brightness between the shadow and the highlight areas of an image.

Byte A standard unit for digital storage, a byte is made up of 8 bits and has a value between 0 and 255. 1024 bytes is equal to 1 kilobyte and 1024 kilobytes is equal to 1 megabyte.

Calibration Matching the output of a device to a standard, for example, to create desired colour reproduction.

CCD Charge coupled device: a semiconductor which can measure light and is the device which is commonly used in many digital cameras.

Channel Information within the image that falls into a group, for example a band of colour such as red or blue.

CMOS Complementary metal-oxide semi conductor, an alternative to the CCD sensor that is widely used in cameras and computers.

Colour gamut Simply the range of colours able to be reproduced by a device and visible to the naked eye. Also the range of colours available within a particular ICC colour profile.

Colour mode The way in which an image presents the colours and tones that it contains. Not to be confused with ICC colour profiles, colour modes include RGB, CMYK and greyscale.

Colour temperature This is a measure of colour quality which is specified in terms of a kelvin rating. A low kelvin rating of 5500 or below renders warm tones while anything over 5500 kelvins renders cool blue tones.

Compression A process where a digital file is made smaller to save storage space. Compression comes in two types: lossy, where the image quality is degraded and lossless, where the original quality of the file is kept intact.

Cloning The process of duplicating pixels from one part of an image and placing them onto another part.

Depth of Field The amount of the image that falls in sharp focus from foreground to background.

Dialogue box A box which allows you to make alterations to the image and view those alterations before finalizing the effect or command.

Digitization The process where analogue image or signals get sampled and changed into their digital form.

dpi Dots per inch, terminology to represent the resolution of a scanner, digital file or printer.

Driver A piece of software designed to control and run an external device from the computer such as a printer or scanner.

Duotone A greyscale image that has the addition of another colour which is not black.

Dynamic range The range of different brightness levels that can be recorded by a digital sensor.

Edge sharpening Image manipulation performed to create higher contrast edges.

Embedded data Data that is tagged onto a file for future reference, this includes ICC colour profiles and Exif data.

Enhancement Changes applied to the image, brightness, colour or contrast, which are intended to improve its appearance.

Exposure The process of allowing light to reach a sensitive medium, such as film or a sensor.

Feather A way of softening the transition from one effect into another and blurring boundary lines. Very useful for making filter effects appear more natural when applied to a selected part of the image.

File format The format in which a digital file is stored. Each format has its own qualities, some use compression to make file sizes smaller whilst others, such as use no compression to preserve the integrity of the image. The format of a file will also determine its flexibility and which programs can read it.

Filter Filters offer a way of applying an alteration to the whole or selectively chosen parts of the image.

Firewire Serial bus technology similar to USB which allows the transfer of data from one medium to another, such as from a scanner to a computer, for example. Firewire offers high transfer speeds, however, it is fair to say that USB and USB 2.0 technology is more commonly used by many Windows-based PC users when connecting external devices including digital cameras.

Flare Non-imaging forming light that is reflected off the inside of the lens often taking the shape of the camera's iris.

Gamma The contrast within the mid-tone detail of a digital image.

Gaussian blur A filter in Photoshop which is designed to soften and blur the image.

Grain The individual particles that make up an image, or the texture of a sheet of paper. The effect of grain can, to a certain extent, be replicated by noise.

Greyscale A monochrome image which is based of 256 tones starting from white and going through a range of grey tones until it reaches black.

Histogram A graph of the spread of pixels tones.

History The ability of Photoshop to display and go back to any previous state that the image was in at any point during the manipulation process. Select **WINDOW → HISTORY** or **WINDOW → UNDO HISTORY** in order to display all of the state changes within the image.

Hue The colour of light as distinct from its saturation and its luminosity.

ICC colour profile
International colour consortium profile. A named colour gamut that harnesses various characteristics.

Image layers The various layers that make up the image, each layer contains part of the image that make up the one image when viewed in whole.

Interpolation A method of increasing resolution by inserting new pixels into the image based on calculations from existing pixels.

Inverse Reversing a selection so that all the pixels that were outside the selected area become selected, while those inside it are deselected.

Jpeg A file format developed by the joint photographic experts group featuring built-in lossy based compression. The compression enables otherwise large image files to take up a far smaller amount of space, with variable quality and compression.

Jpeg 2000 A newer version of the jpeg file, being more flexible and allowing better quality, creating less visible artefacts.

Kelvin The unit of measurement used to express colour temperature within an image, 5500 kelvins as indicative of normal daylight, below this temperature images become progressively warmer and above this temperature images become progressively more cold unless compensated for.

Keyboard short-cut
Designated keys in Photoshop either preset or changeable by the user to run commands at a key stroke.

Keytone The main tone in the image which is of greatest importance.

Lasso Freehand method of being able to draw around areas of the image to make a selection.

Layer A floating copy of the original image which sits on top of the background image, multiple layers may be opened with different effects applied to each one. They are like virtual sheets of acetate sitting on top of the image. To preserve layers for future manipulations the image must be saved as a PSD format file.

Layer opacity The opacity or transparency of each layer covering the background image. As the opacity is changed the layers beneath become more or less visible. This can be used to vary an effect that is only applied to one layer.

LCD Liquid crystal display, most digital camera preview screens and laptop computer screens are LCD screens.

LZW compression Lempel-Ziv Welch: a form of lossless compression which is commonly applied to tiff files.

Megapixel One million pixels, multiples of which are commonly used to denote the resolution of digital cameras' sensors.

Magic wand tool A tool which allows you to select similar groups of pixels based on their colour tone, tolerances can be changed to choose a wider or narrower selection of pixels.

Mask A technique which allows the user to mask off areas which will be excluded from the various manipulations applied to the image.

Monochrome An image made up solely of various tones of grey, or for that matter any other single colour.

Nearest neighbour An interpolation method where neighbouring pixels are used to create new data in order to increase the image size of a file. Generally used for line drawings and largely unsuitable for interpolating photographs.

Noise The equivalent of digital grain, noise represents a distortion in original data that is often caused by high ISO setting and poor exposure or over-manipulation of images.

Opacity The transparency of an effect that has been applied to an image, or the transparency of one layer that is placed over another, this is controlled by the opacity slider in the layers pop up box.

Optical resolution The resolution that a scanner can sample from an original file.

Out of gamut A term that relates to colour that can be seen and reproduced in one colour space, but are not seen or reproduced when taken into another colour space, such colours are termed as being 'out of gamut'.

Palette A menu within the editing mode allowing select changes to the colour and the brightness of an image.

Pixel Smallest part of the image, the building block of the image, short for picture element.

Pixelation The visibility of individual pixel edges within an image, often caused by excessive enlargement.

ppi pixels per inch, input resolution measuring the number of points that are seen by a device by the linear inch.

RAM Random access memory. A rapid form of memory communication where the computer stores data in order to process functions. Photoshop itself is very dependent on RAM requiring approximately five times the image size in order to run smoothly.

Raw A generic term for the many proprietary file formats that are produced by different manufacturers' digital cameras, which retains flexibility in some shooting parameters.

RGB A colour mode where all the colours within an image are made up of red, green and blue. RGB is the most commonly used colour mode for digital cameras, scanners and bitmap-based programs.

Resampling Changing an image's resolution by either removing pixel information and thus lowering the resolution, or by adding pixels via interpolation thus increasing the resolution of an image.

Rubber stamp Another name for the clone tool in Photoshop.

Selection An area of the image which is defined by a border as selected using one of the selection tools in Photoshop.

Thumbnail A low-resolution preview image of a larger image file, used to check what the image is before opening the full-sized file.

Tiff Tagged image file format. A format that is widely used by professionals as it is compatible with both Macs and PCs and also features the ability to perform lossless compression when saving an image, thereby losing no image quality.

Tolerance Controls the amount of pixels that will be selected by a command or function within Photoshop, setting a low tolerance will affect fewer pixels and a high tolerance more pixels.

Twain Toolkit without an important name; A driver that is used with computers to operate a scanning device.

USM abbreviation for unsharp mask, process where the image is sharpened using the unsharp mask filter in Photoshop.

Vignetting Refers to two types of effect, one being where a device such as a lenshood infringes on the final image, resulting in darkened edges and loss of light around the edges of the image. Vignetting is also used as an artistic effect, in terms of deliberately darkening around the edges or softening around the edges of the image, see page 159.

WYSIWYG What you see is what you get, a computer interface designed to show on the computer screen the exact colour production which should, if the colour profiles are consistent, be matched in print.

GLOSSARY

Index